Published by
Cazu Productions and Publishing
mail@alcazu.com

Copyright © Alan Williamson

All rights reserved. No part of this publication may be produced, stored in a retrieval system, or transmitted, in any form or by any means, electronic, mechanical, photocopying, recording or otherwise, without the prior
permission of the copyright holder.

ISBN-13: 978-1523378531 (CreateSpace-Assigned)
ISBN-10: 1523378530

Introduction

With regard to the pictures and models that I produce I have very often been asked: 'What does it mean? What were you thinking? Why did you do that?'

This portfolio of images and words is intended to answer some of those questions.

To the best of my own understanding I produce these works because I have no choice but to do so. Maybe it is because it is my own way of attempting to figure out just what they mean.

The words are extracts from my journals. Sometimes the words drive the image, at other times they may be my own attempt to explain the work to myself, or they are an interpretation of my thoughts while creating the work.

I would like to dedicate this portfolio of my work to those who have been close to me in my life, those who seemingly agree to say "Never live with an artist". I can't disagree with that sentiment but personally I have had no other alternative.

Al Cazu

1) Background image: 'Submerged'
Media: Watercolour
Size: 340 * 540 mm

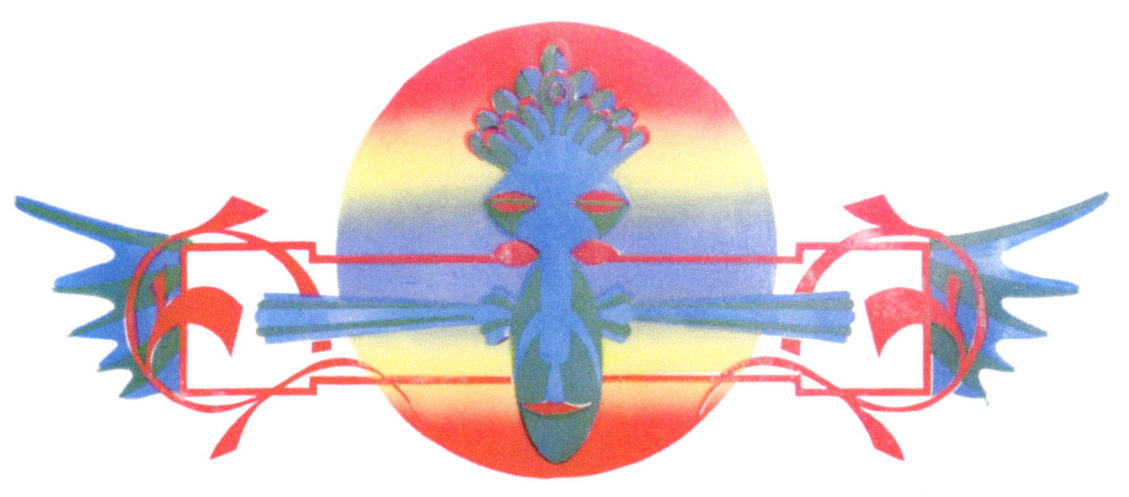

The rhythm seems peculiar, and the notes are all jumbled up. These are strange but pleasant sounds. The chords don't seem to fit right, and the tempo moves around. It's not until you get it that you know just what it's all about.

2) 'Mars'
Media: Linocut Print
Size: 300 * 200 mm

MIND'S EYE

Waiting there, a secret rhyme. What will it bring?
A place where anything can happen.
Happiness, disaster, pleasure, calm.
Coming soon, it's almost here.
Arrived and now it's gone.
More to come.

No time to wonder how this came about.
Directions to choose, decisions to be made.

Sometimes sure, occasionally confused.
Over halfway there, what's the hurry?
Don't want to miss one single wonderful thing.

Hear the warnings, move with care.
Navigate with heart and mind.
Be prepared to float and drift, take rest,
and then swim strong.

The path can be narrow, wide, level, steep.
Always winds but never ends.

Plan, try, dream, hope, and move along.
Made of happenings, laughter, pain, joy,
and those now long forgotten.
Distant places other lives.

So many passed that way.
Teachers, livers, lovers.
Some survived while others gone.

A time to visit, look back, reflect.
Lessons learned, gains, and loses.
Dreams, and defeats.

Like a foreign land, always just a little strange.
Nothing there can be changed, it is the way it was.

3) Background image: 'Horizons'
Media: Watercolour
Size: 340 * 540 mm

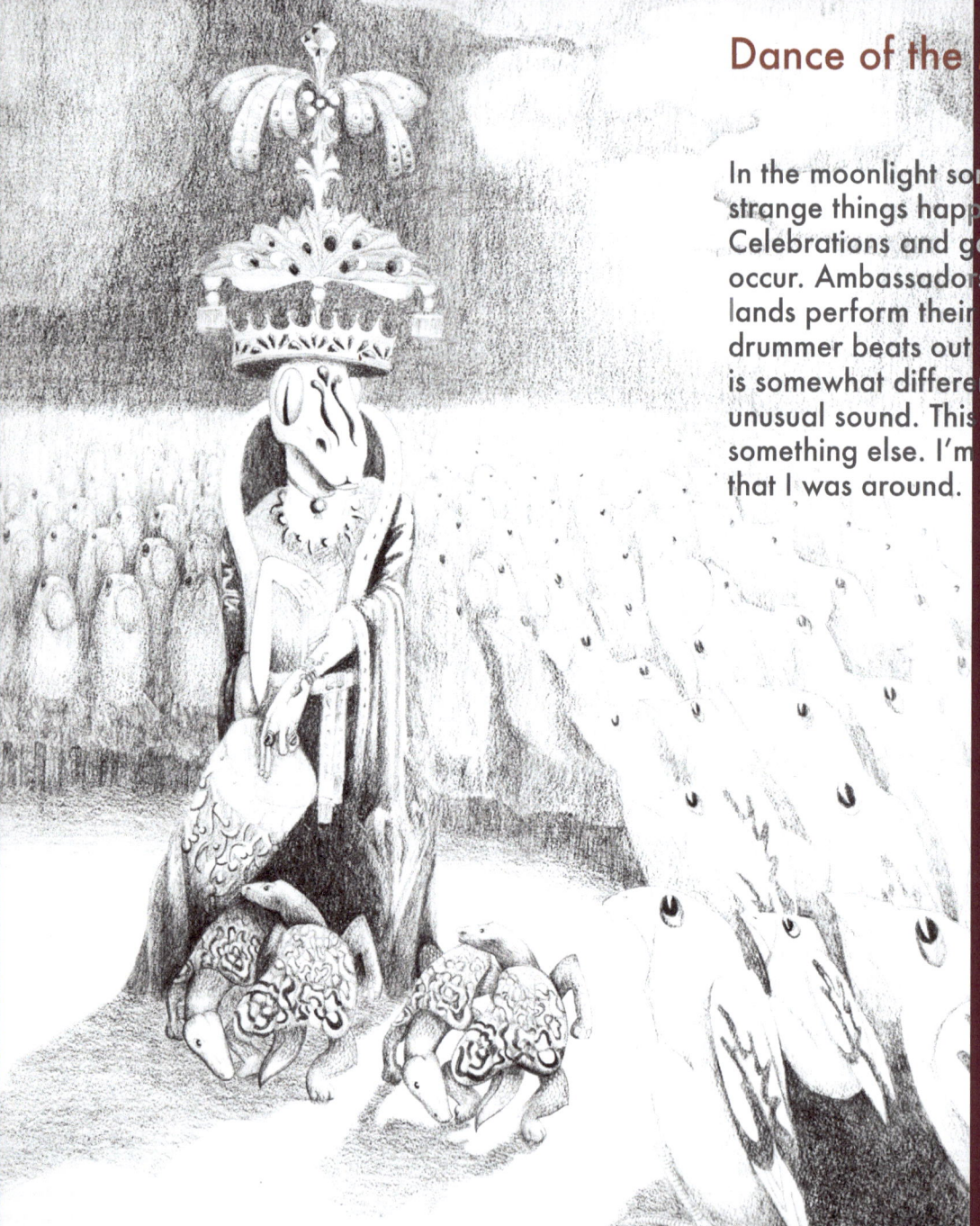

Dance of the Mooncons

In the moonlight sometimes strange things happen. Celebrations and gatherings occur. Ambassadors from magic lands perform their dance. The drummer beats out a rhythm that is somewhat different. It's a very unusual sound. This meeting is something else. I'm so glad that I was around.

4) Media: Lithograph
Size: 340 * 240 mm

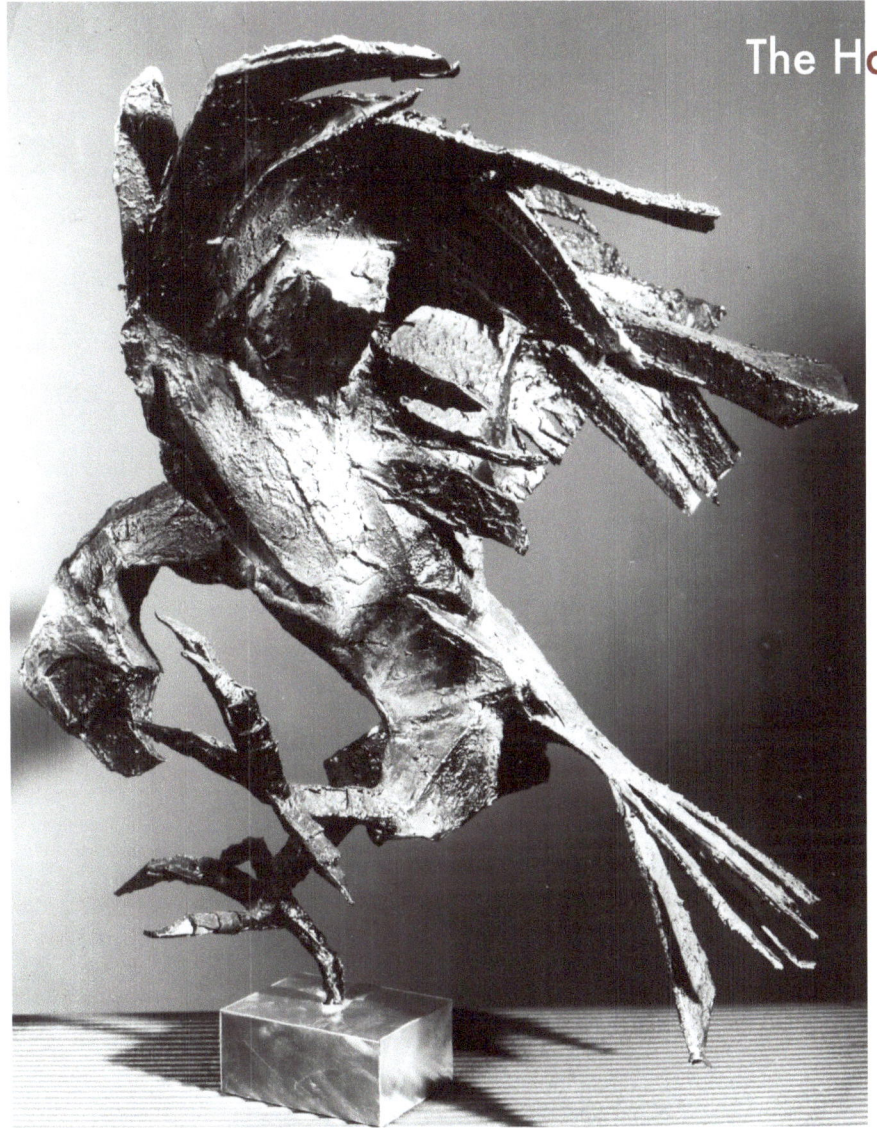

The Harrier

5) Media: Simulated Bronze
Hight: 750 mm

Like the pregnancy of a forthcoming idea, not unlike that blank canvas awaiting the artist's first touch. An icon for the music that is not as yet composed, or the words that are soon to be written. She hovers above waiting for the moment of chance. When the perfect time arrives she will dive on her intention and her strong talons will grasp the opportunity with unrelenting determination.

Silver Lining

As they say (who ever 'They' may be?)
"Every cloud has a silver lining".

During dark times when bad things happen this metaphor becomes rather hollow. However, in the course of time all clouds pass over.

Maybe it is time itself that is the hero that enables us to endure.

6) Media: Watercolour
Size: 340 * 540 mm

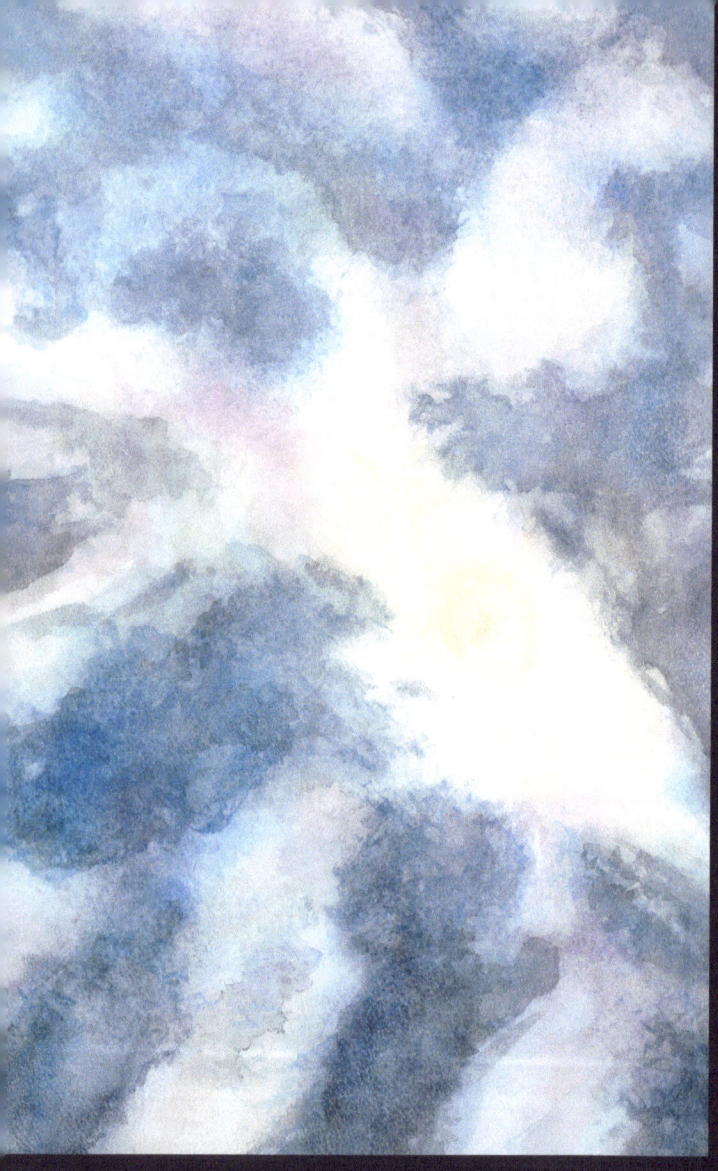

Mystery

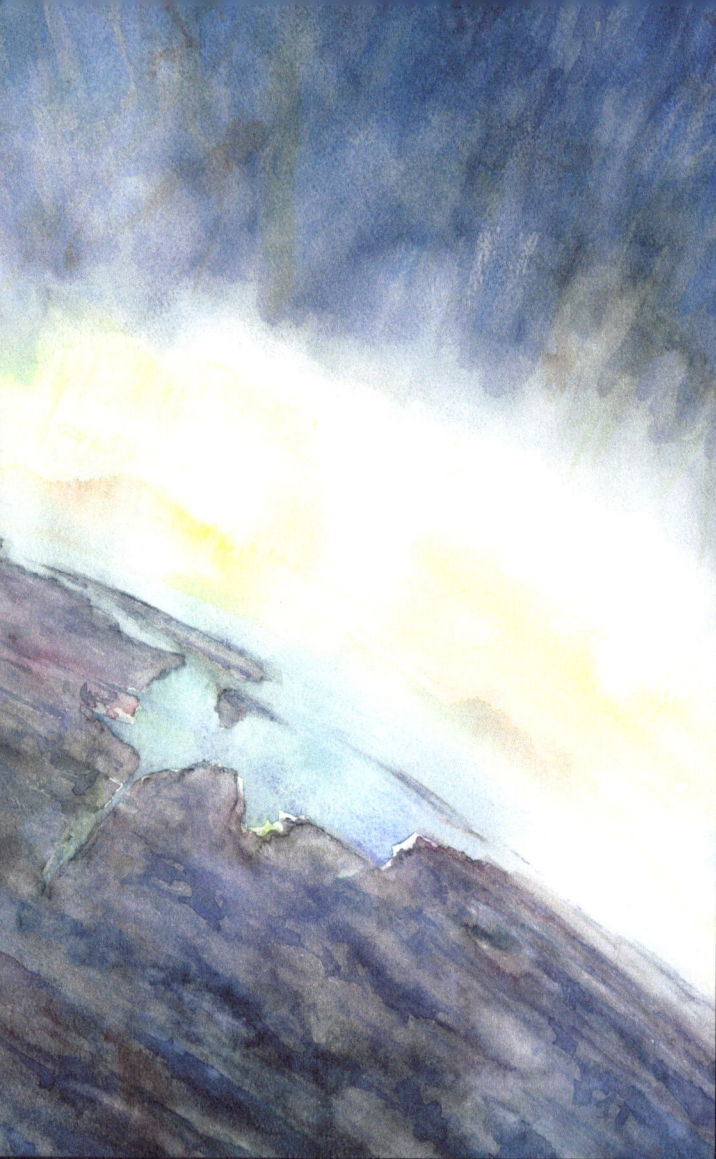

Fear

Huge Adventure

It is a journey that we all must take. Few avoid the milestones that are to be found along the way. The destination is inevitable. No one is here to stay. What ever path is taken, plans made, or ideals adopted. The ticket price remains the same.

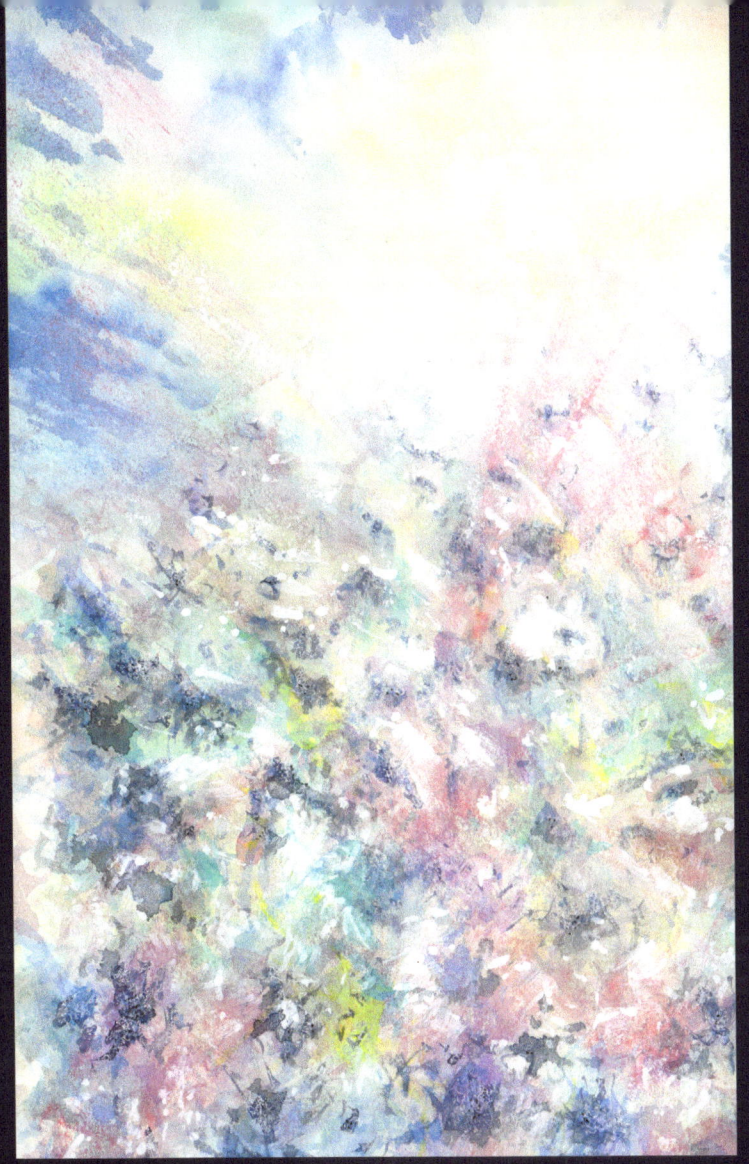

Pleasure

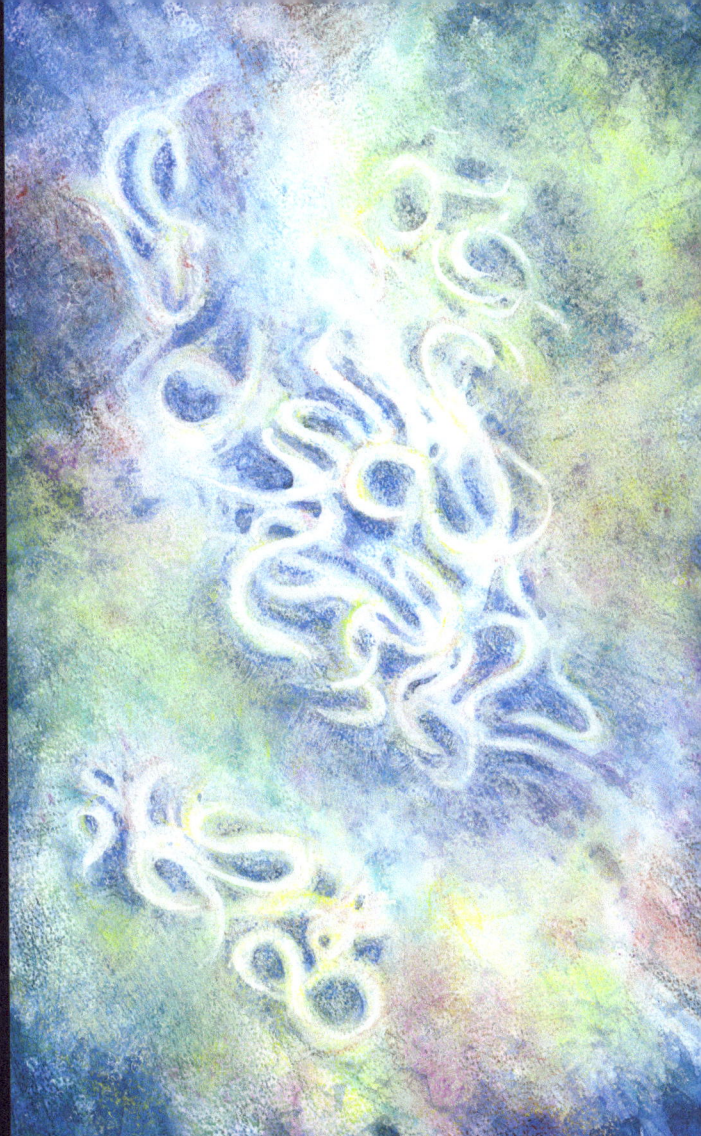

Pain

7) 8) 9) 10) Media: Watercolours
Size: 540 * 340 mm

It can bring triumph, or disaster, happiness, even pain. No script on offer, nor prescribed rules. It's not a game. There is no choice; you've embarked upon this venture. Never will you be the same again.

11) Media: Lithograph
Size: 340 * 240 mm

Lady Grey

Lay Lady Grey went mad today.
Nobody knows where a mad lady goes
when she's out of her mind.

Dear Lady Grey can't think straight from day to day.
She won't be coming back
Along her way she left her mind behind.
It has to be said that although she doesn't utter a word
and always appears to be confused,
apart from that she seems to be perfectly OK.

The Factory

What an awful place to work. If the boredom and drudgery aren't enough to break your spirit, the unbearable noise and stink will bring about a living hell.

13) Media: Ceramic
Hight: 295 mm

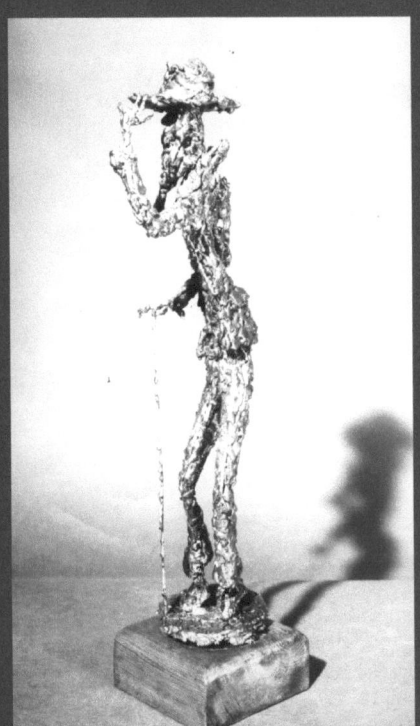

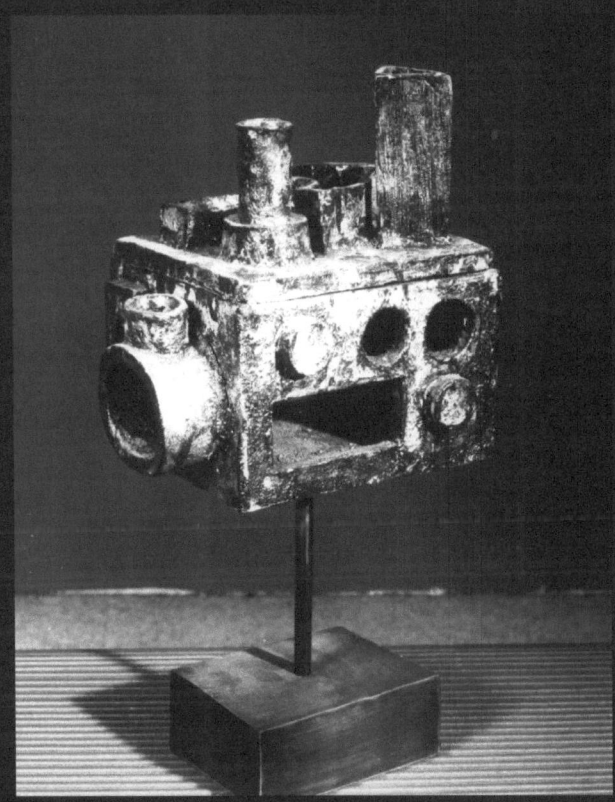

Mr Winds

My dear old friend leaned forward into a stiff breeze, he eventually ended up in Madrid where he still stands tall today.

12) Media: Brass
Hight: 300 mm

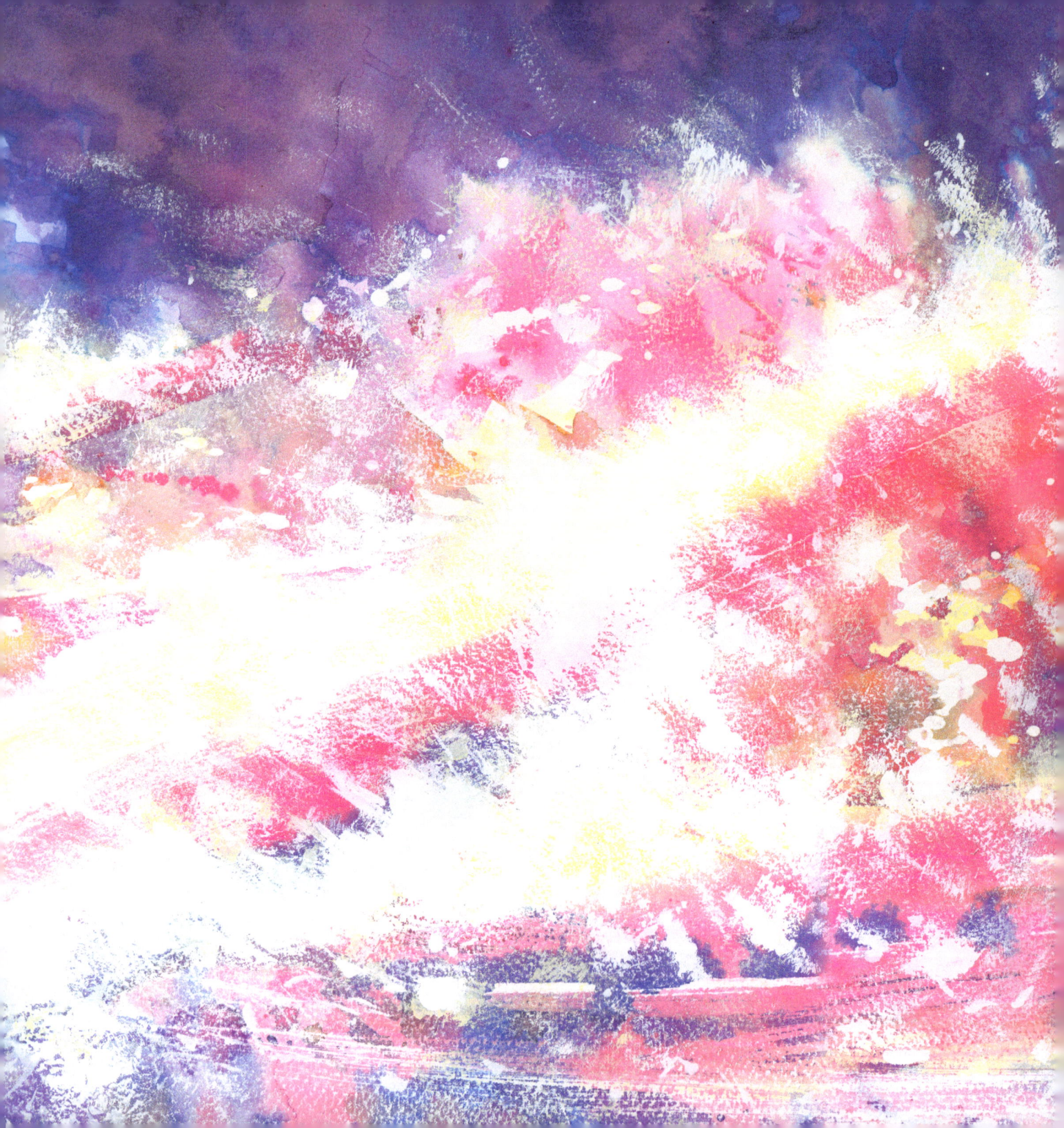

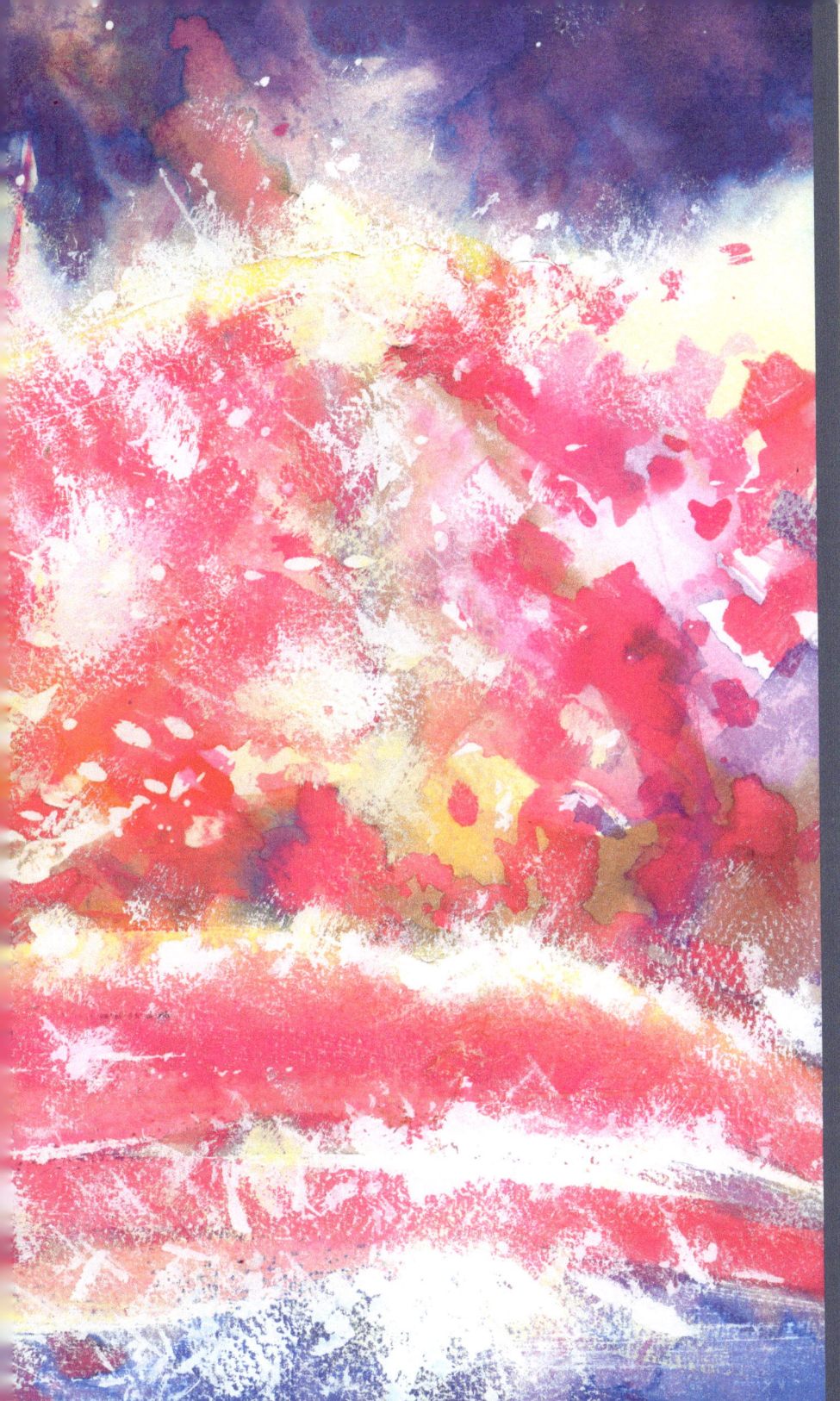

Too Hot to Handle

Tantalizingly attractive, all consuming, and far too dangerous to consider. Sometimes unexpected, uninvited, and without explanation. Stolen from the Gods. Can't always be contained. Can become a monster. Brings comfort or disaster. Anything or anyone that finds the way inside will learn to know the flames.

14) Media: Watercolour
Size: 340 * 540 mm

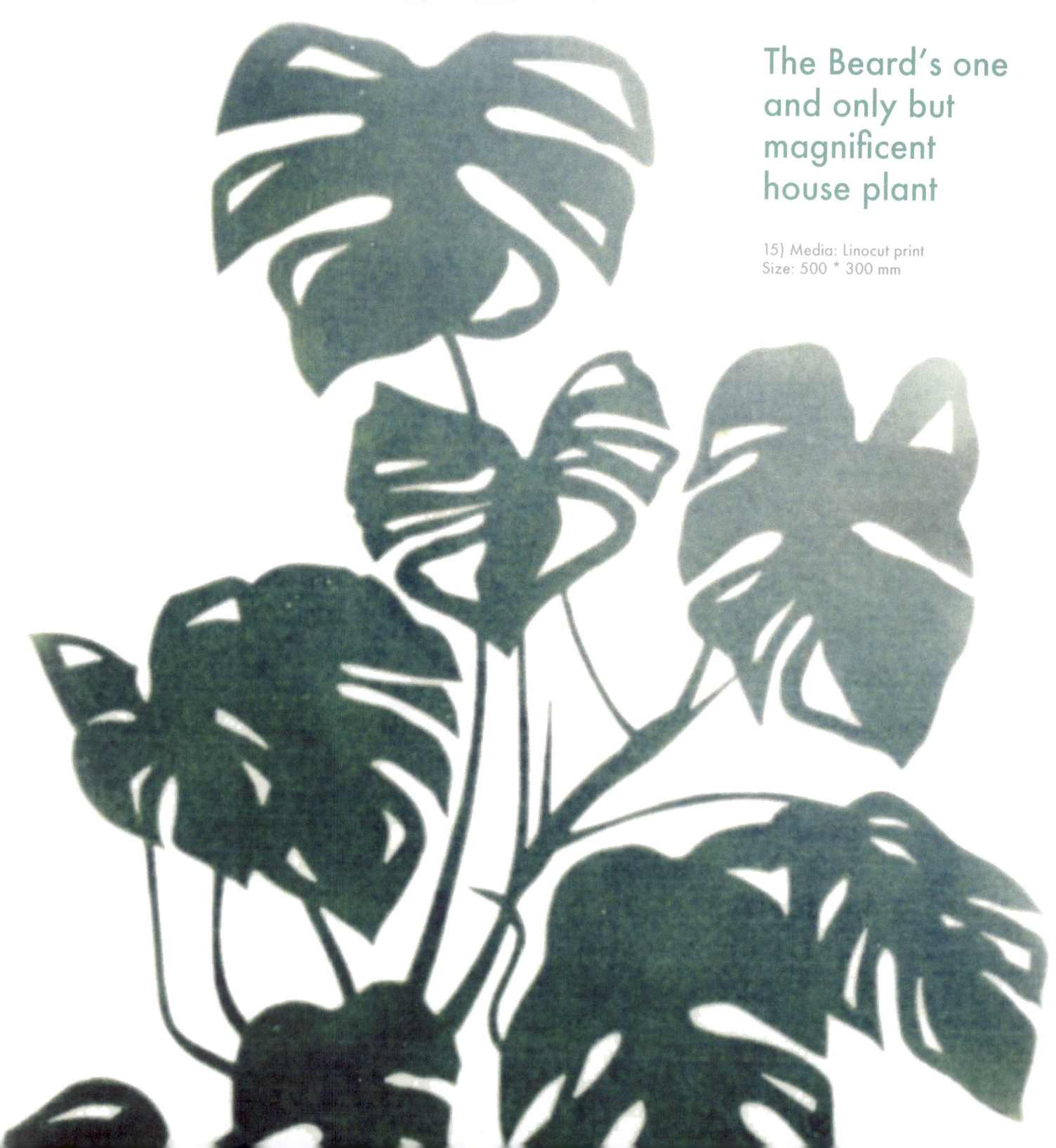

The Beard's one and only but magnificent house plant

15) Media: Linocut print
Size: 500 * 300 mm

Hide & Seek

Eyes tightly covered,
counting to one hundred,
97, 98, 99, 100, and it's
time to seek.

Searching in the bushes,
through the undergrowth,
behind the rocks, and in
the woods.

It's a competition that
sooner or later will
be won.

Very quiet and secret
remains the bounty
being seeked.

The time comes when the
seeker is successful but
is saddened because the
seeking is all done.

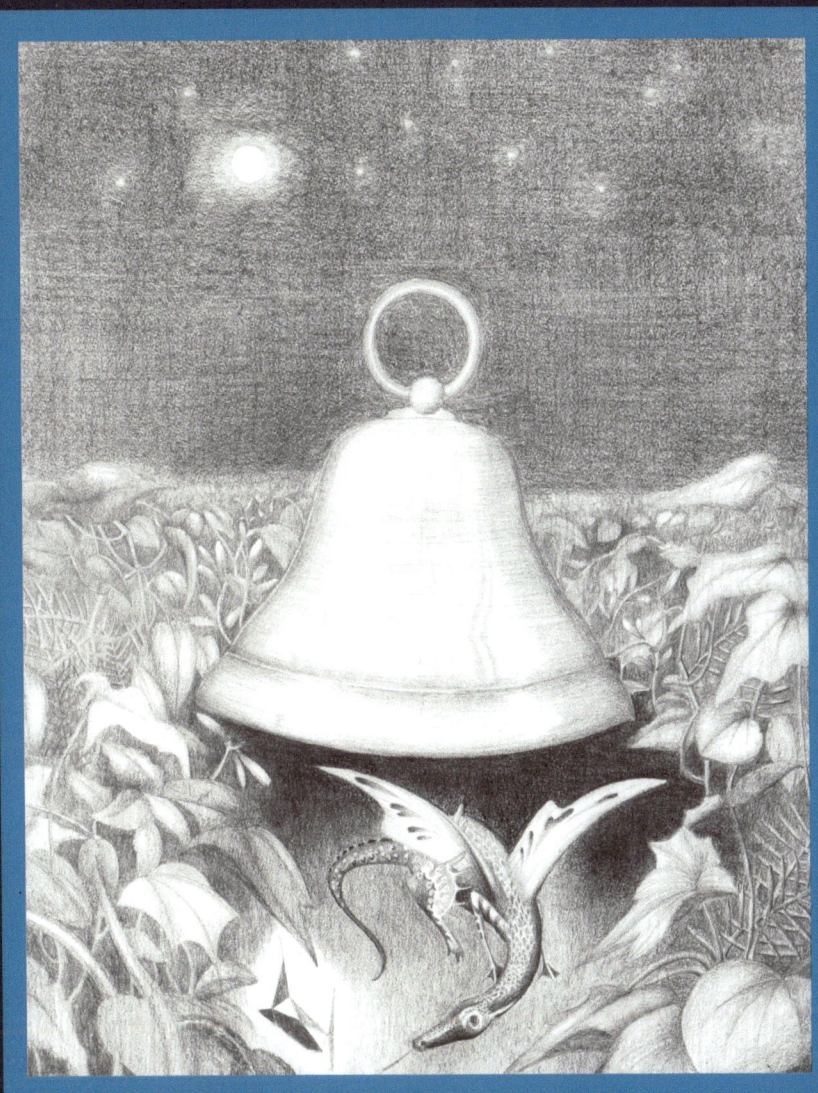

16) Media: Lithograph
Size: 340 * 240 mm

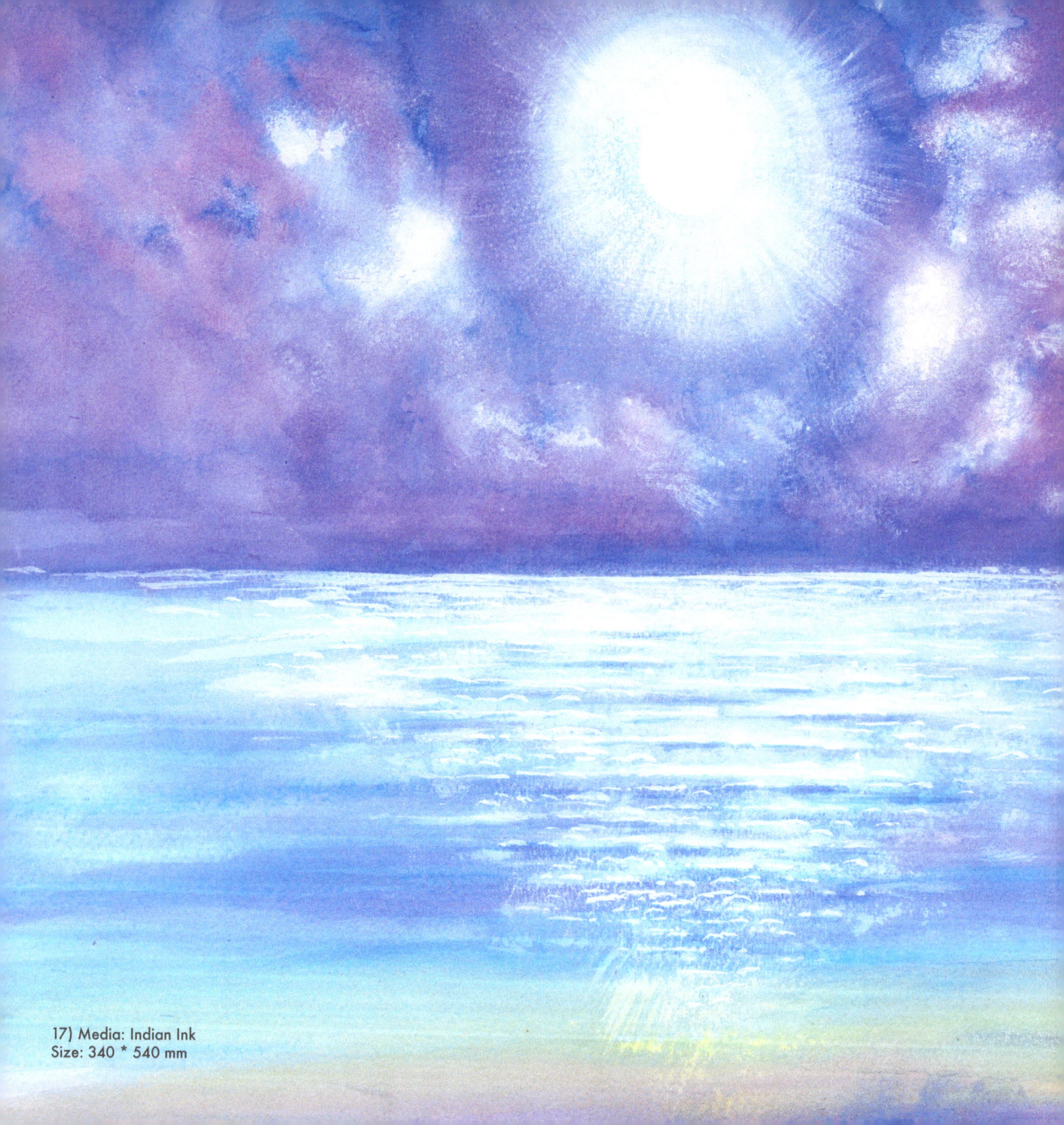

17) Media: Indian Ink
Size: 340 * 540 mm

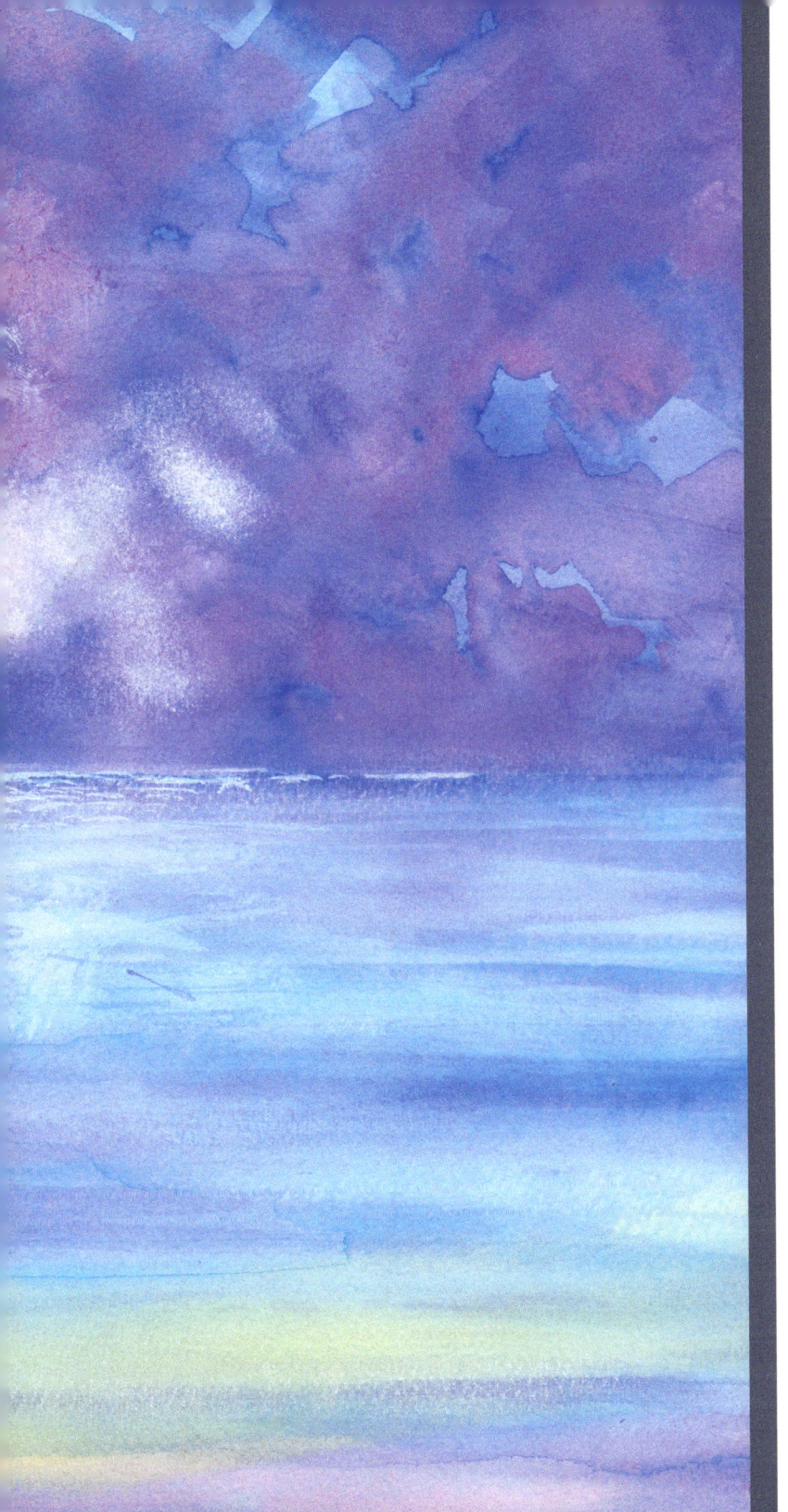

Over the Rainbow

There are such things as can't be heard nor seen but yet they do truly exist.

Some things can be deafeningly loud but remain invisible.

Others we can see but are impossible to touch or hear.

The rainbow offers great beauty but it's start and finish can never be found. If and when you get too close it simply disappears.

Graciosa

Love affairs with islands can be precarious ventures to take. The journey may possibly be exciting but what you find may not be exactly what was expected. It might even break your heart. Peninsulas are far safer but much less private.

18) Media: Watercolour
Size: 340 * 540 mm

Over Her Shoulder

If our magnificent sun that brings us light, warmth, and energy ever took a lover it was most likely to have been the moon.

Their relationship enables the sun to illuminate the daily hidden side of the earth.

In the hours of darkness earth can look over her shoulder and be reassured by the magic of the moon.

19) Media: Watercolour
Size: 540 * 340 mm

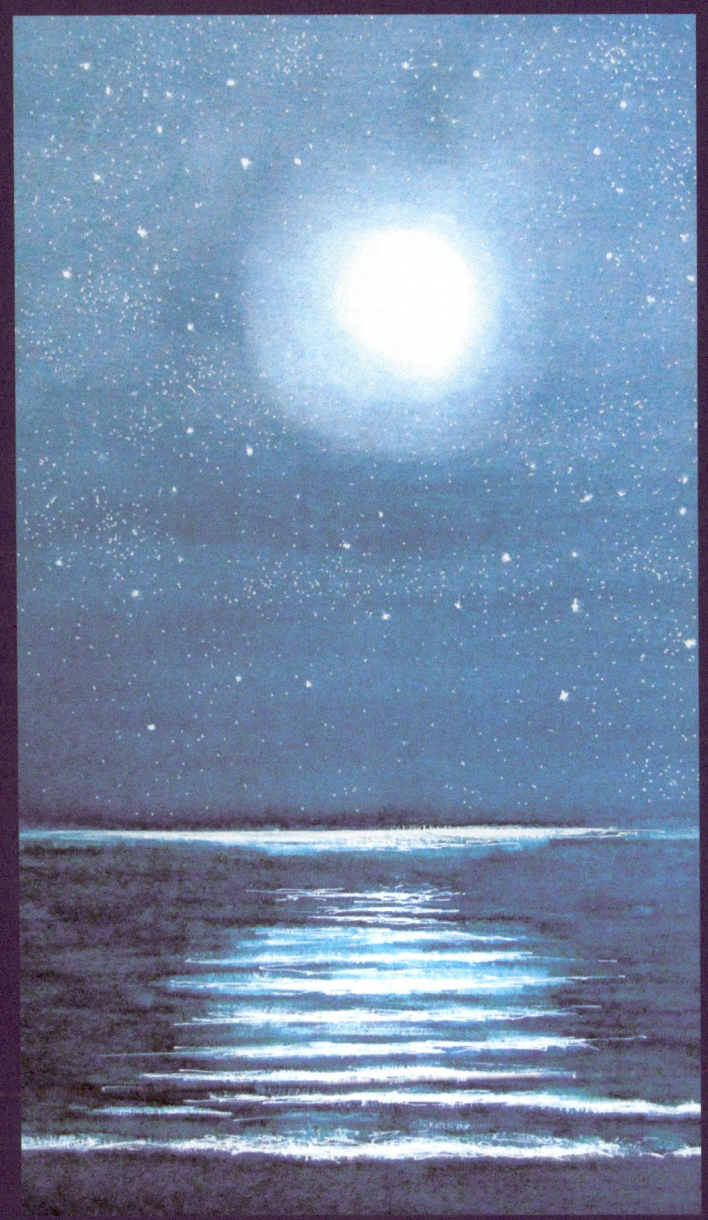

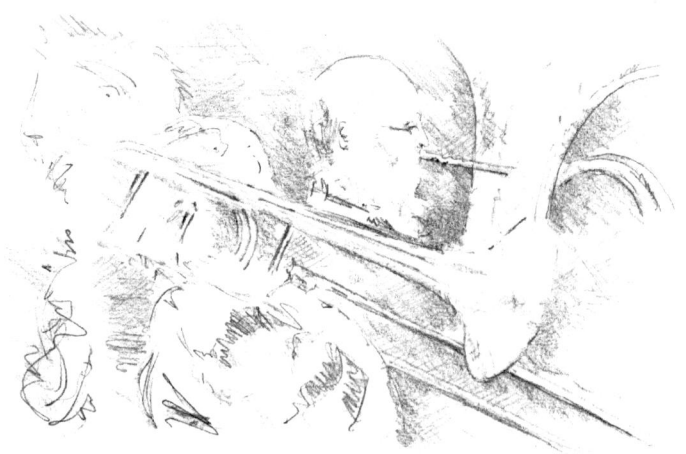

Heavenly Brass

Heard them from a distance, could not help but to follow that oh so mesmerizing sound. Their golden blasts became intoxicating and the audience were spellbound.

Louder than Thunder

We are so sure that we know why things happen because the scientists tell us so. There was a time when the ancients and the mystics told us differently. Maybe both are wrong and truth is something we should already know.

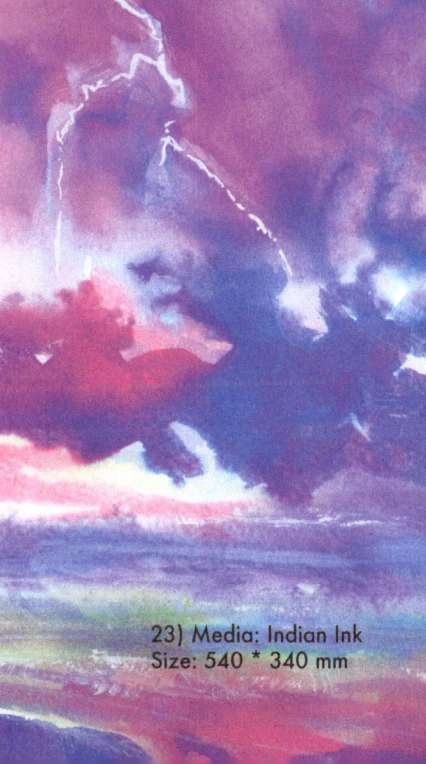

23) Media: Indian Ink
Size: 540 * 340 mm

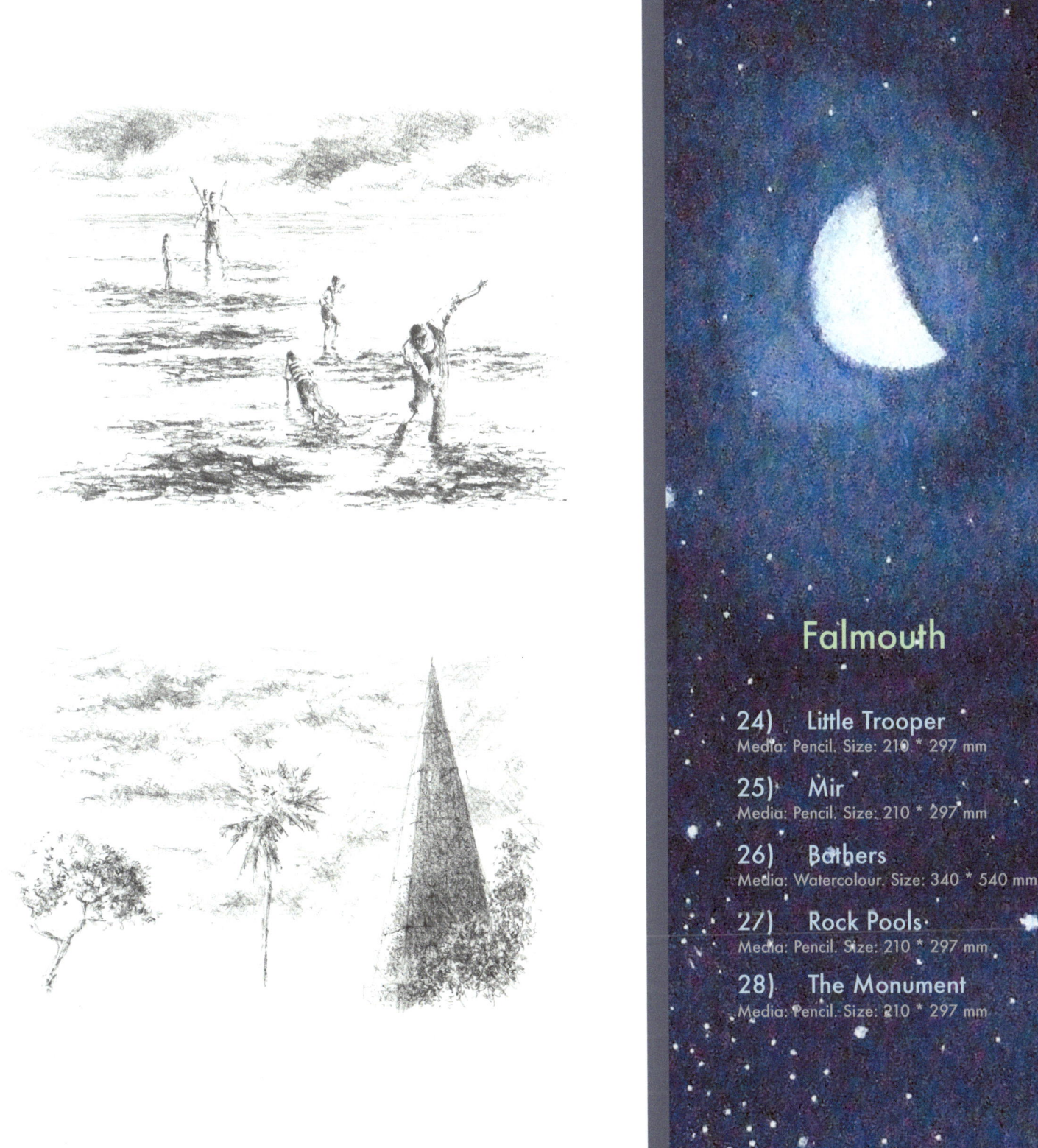

Falmouth

24) Little Trooper
Media: Pencil. Size: 210 * 297 mm

25) Mir
Media: Pencil. Size: 210 * 297 mm

26) Bathers
Media: Watercolour. Size: 340 * 540 mm

27) Rock Pools
Media: Pencil. Size: 210 * 297 mm

28) The Monument
Media: Pencil. Size: 210 * 297 mm

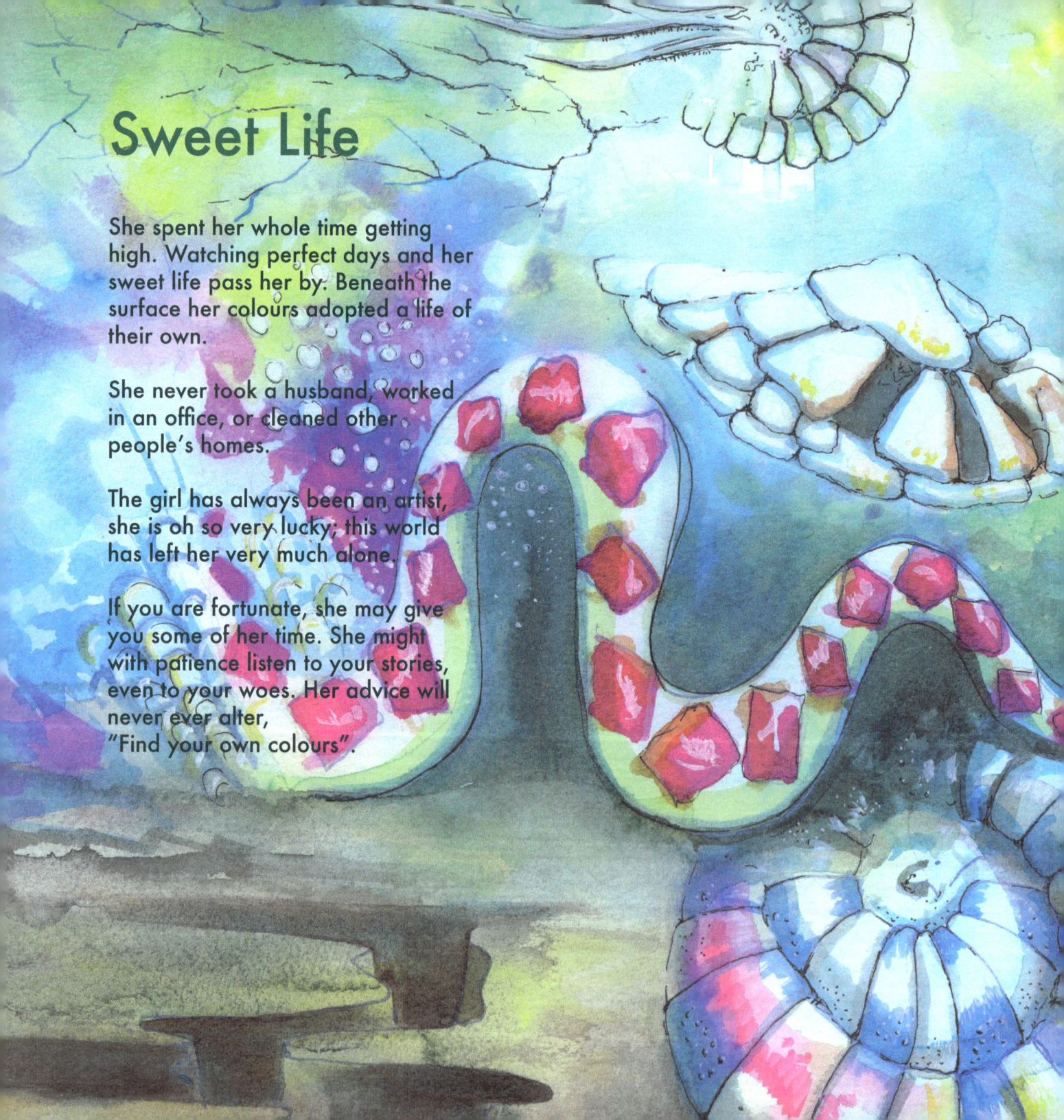

Sweet Life

She spent her whole time getting high. Watching perfect days and her sweet life pass her by. Beneath the surface her colours adopted a life of their own.

She never took a husband, worked in an office, or cleaned other people's homes.

The girl has always been an artist, she is oh so very lucky; this world has left her very much alone.

If you are fortunate, she may give you some of her time. She might with patience listen to your stories, even to your woes. Her advice will never ever alter,
"Find your own colours".

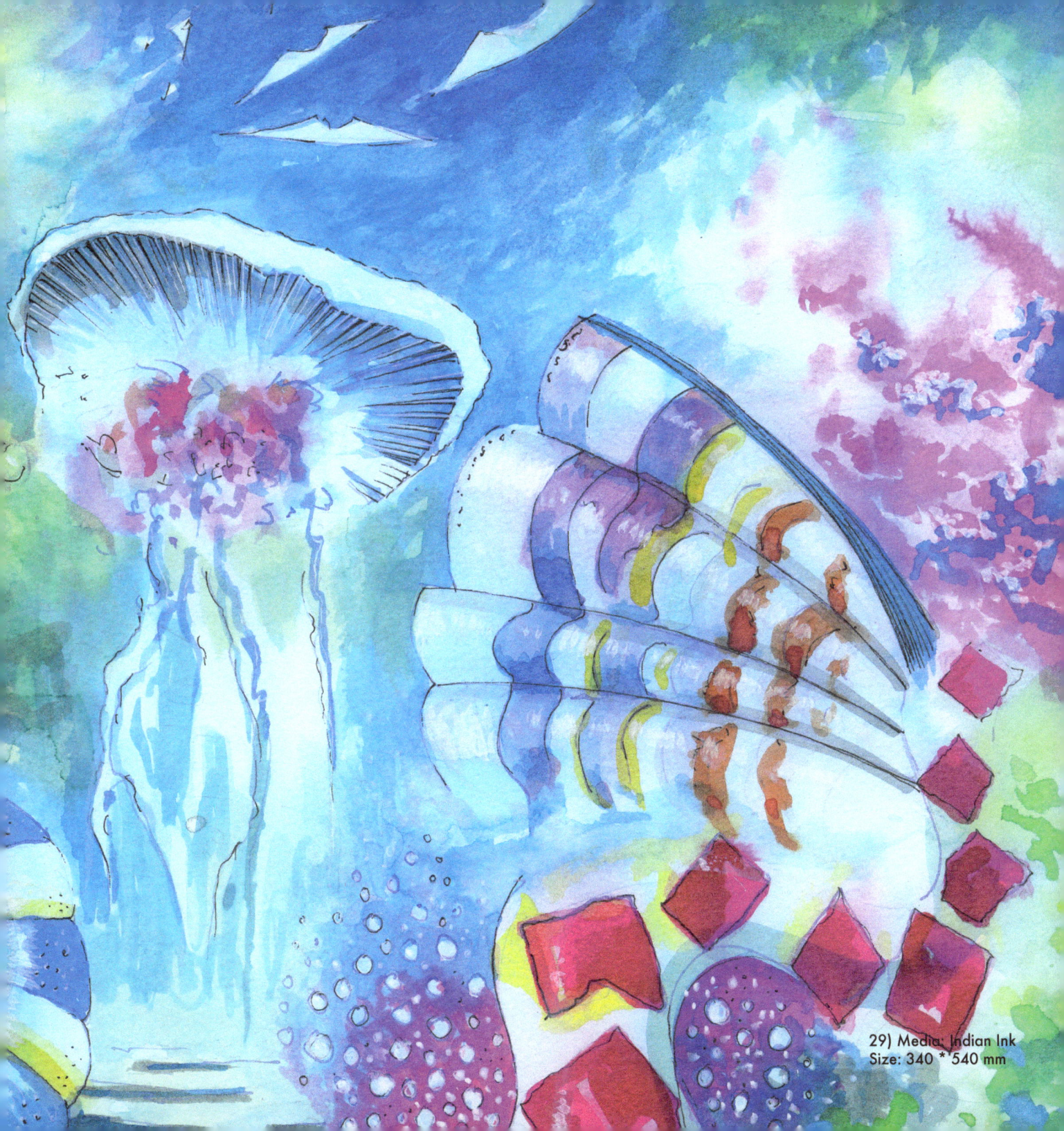

29) Media: Indian Ink
Size: 340 * 540 mm

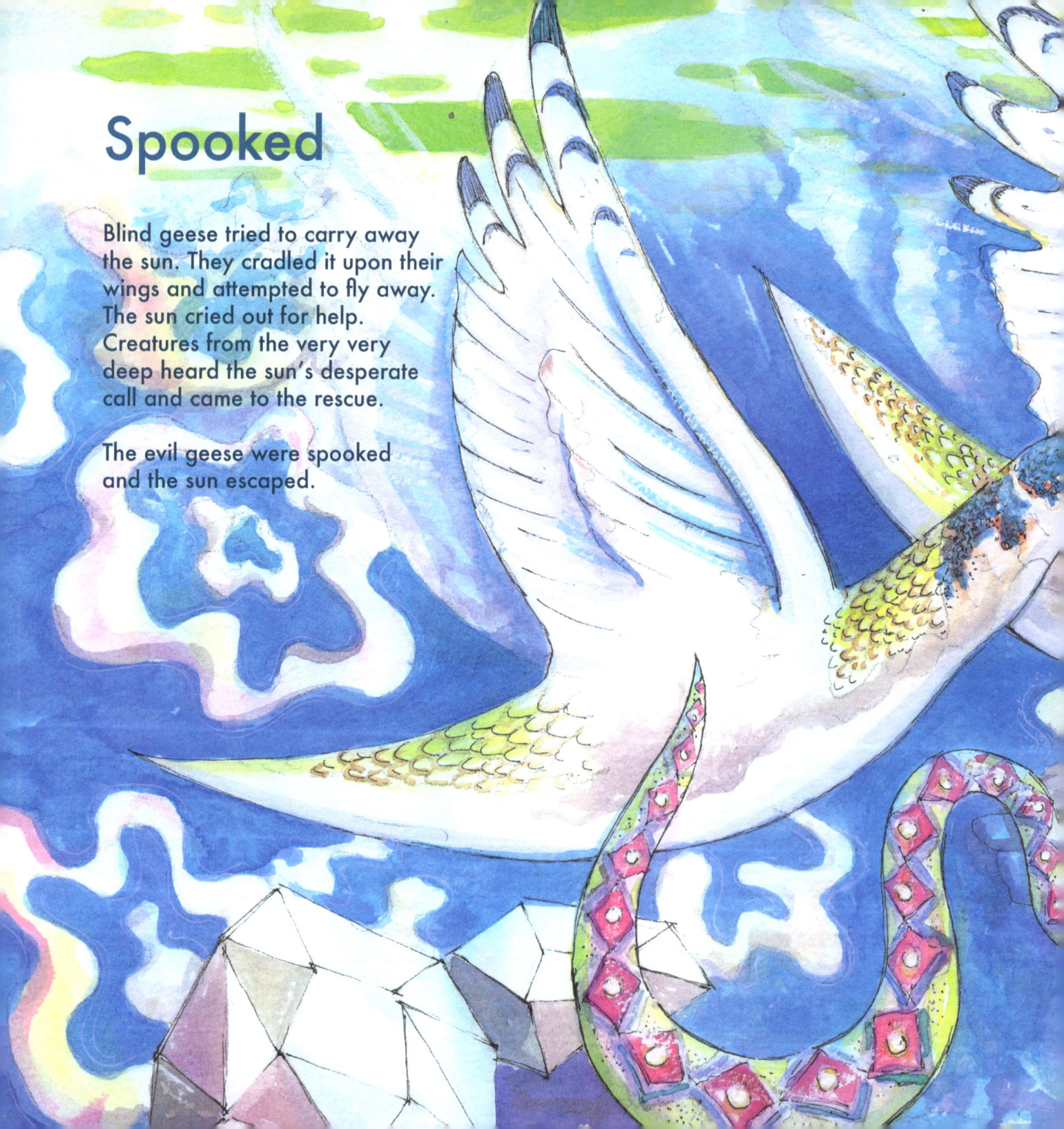

Spooked

Blind geese tried to carry away the sun. They cradled it upon their wings and attempted to fly away. The sun cried out for help. Creatures from the very very deep heard the sun's desperate call and came to the rescue.

The evil geese were spooked and the sun escaped.

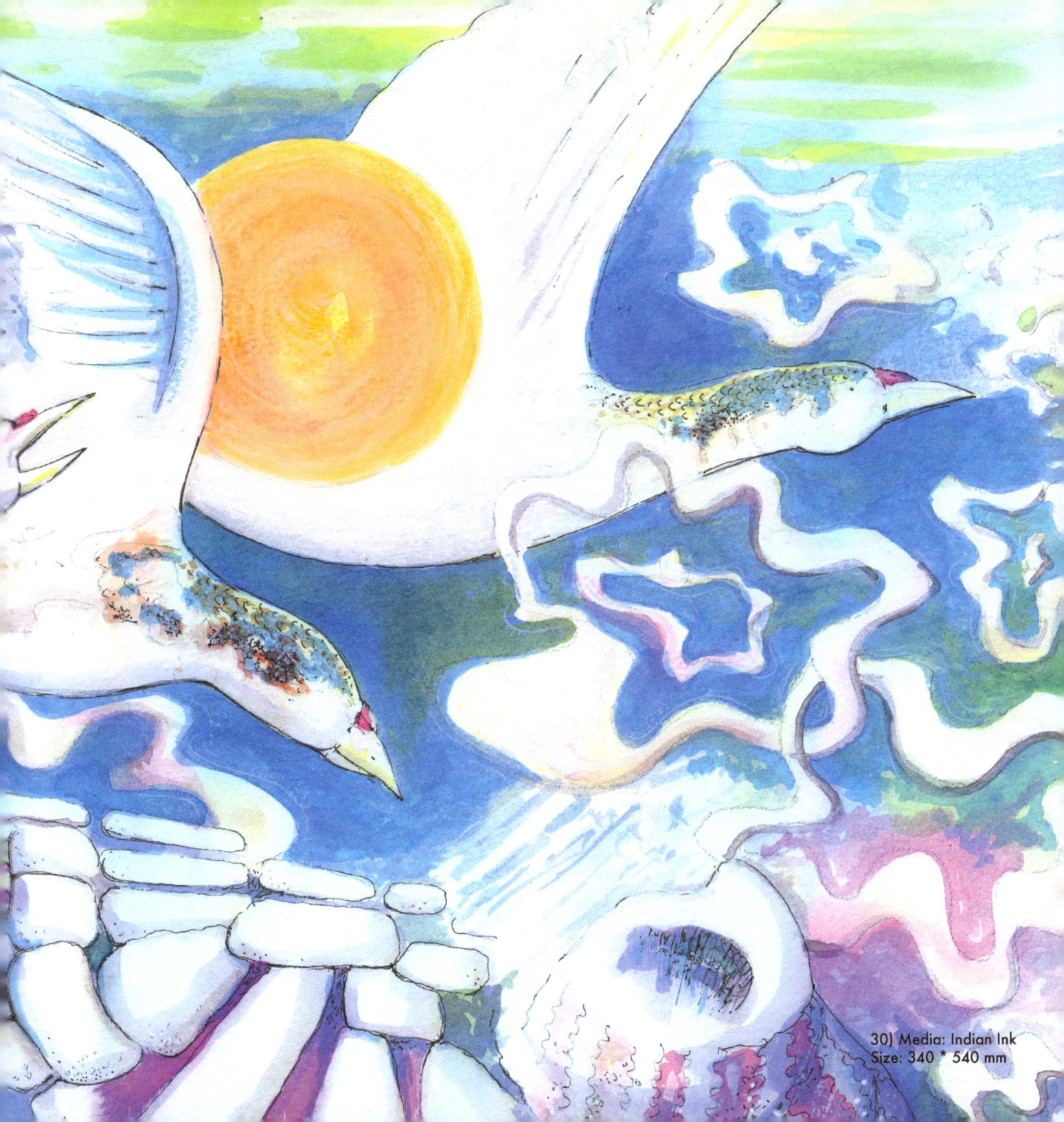

30) Media: Indian Ink
Size: 340 * 540 mm

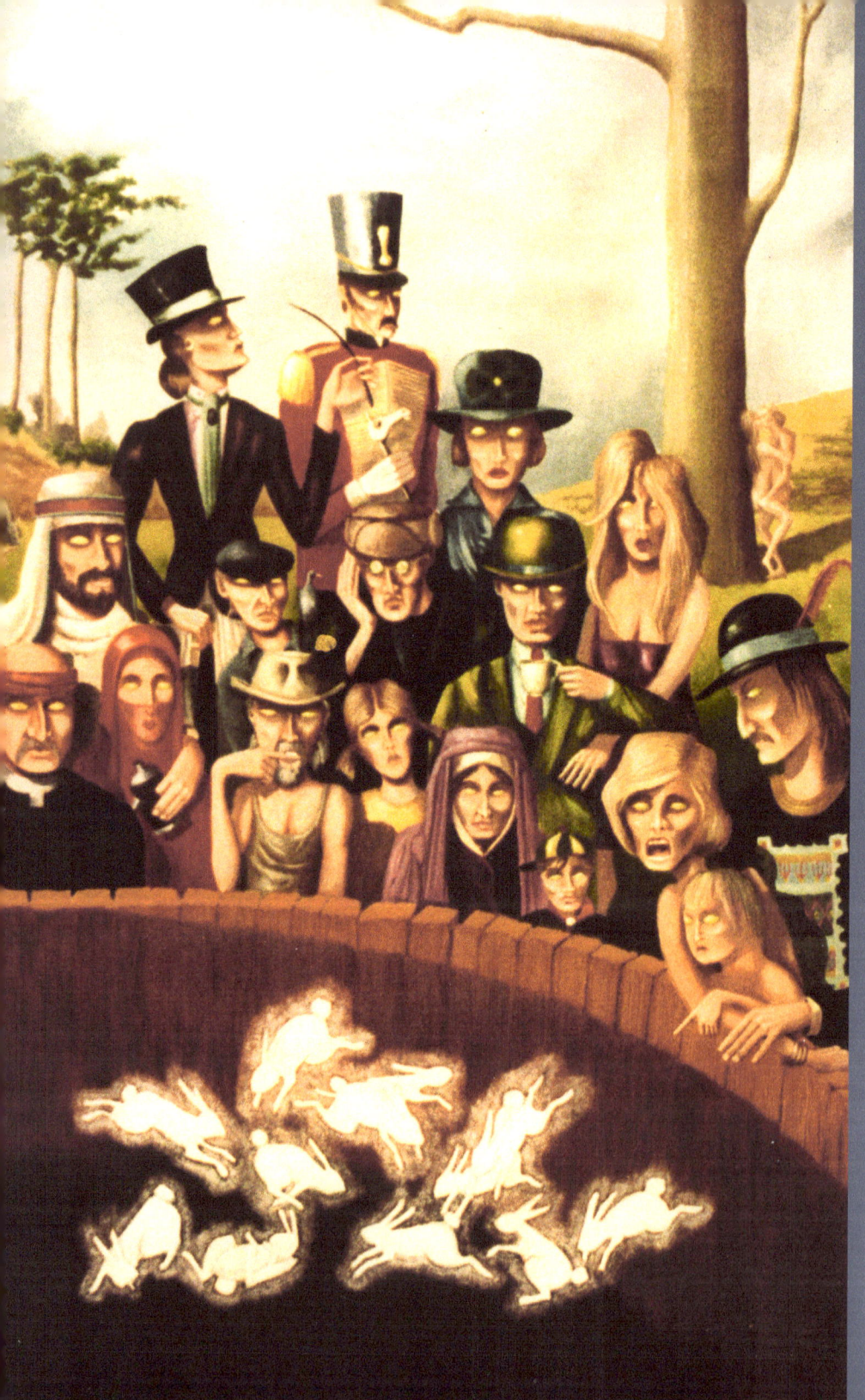

Circus Sunday

Hypocrites, liars, thieves, and cheats. Helpers, lovers, saints. Scoundrels, tricksters, pretenders, bullies, brutes, and imposters. Healers, teachers, and those who try to put things right.

Gamblers, romancers, exploiters, believers, deceivers, and those who like to fight.

Killers, trespassers, doers, thinkers, makers, and inventors.

Planners, workers, creators, givers, and takers. Innovators, facilitators, builders, and destroyers.

All of us have some of these traits. Sadly some people have all of them.

31) Media: Oil on Canvas
Size: 1080 * 680 mm

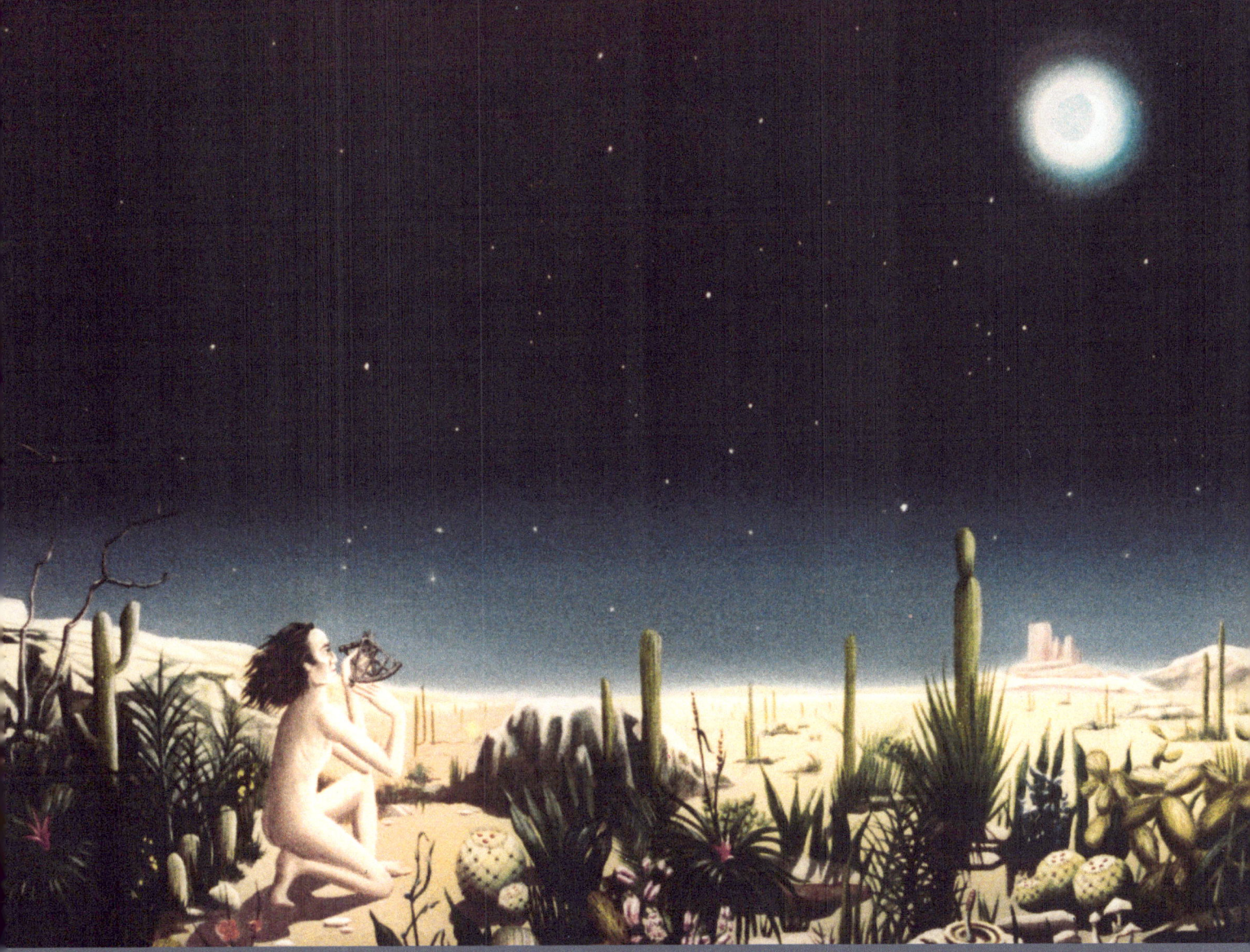

The Navigator

32) Media: Oil on Canvas
Size: 680 * 1080 mm

The desert is a wondrous place by day. Although the scarcity of water and the extremely high temperatures make it to be a somewhat inhospitable habitat many life forms thrive in this arid terrain. After the sun goes down and the sky fills with innumerable twinkling stars the blue moon illuminates the hallucinogenic plant life that grows upon these strange lands. It is during these cooler times that the navigator explores the desert. Where I wonder is he going?

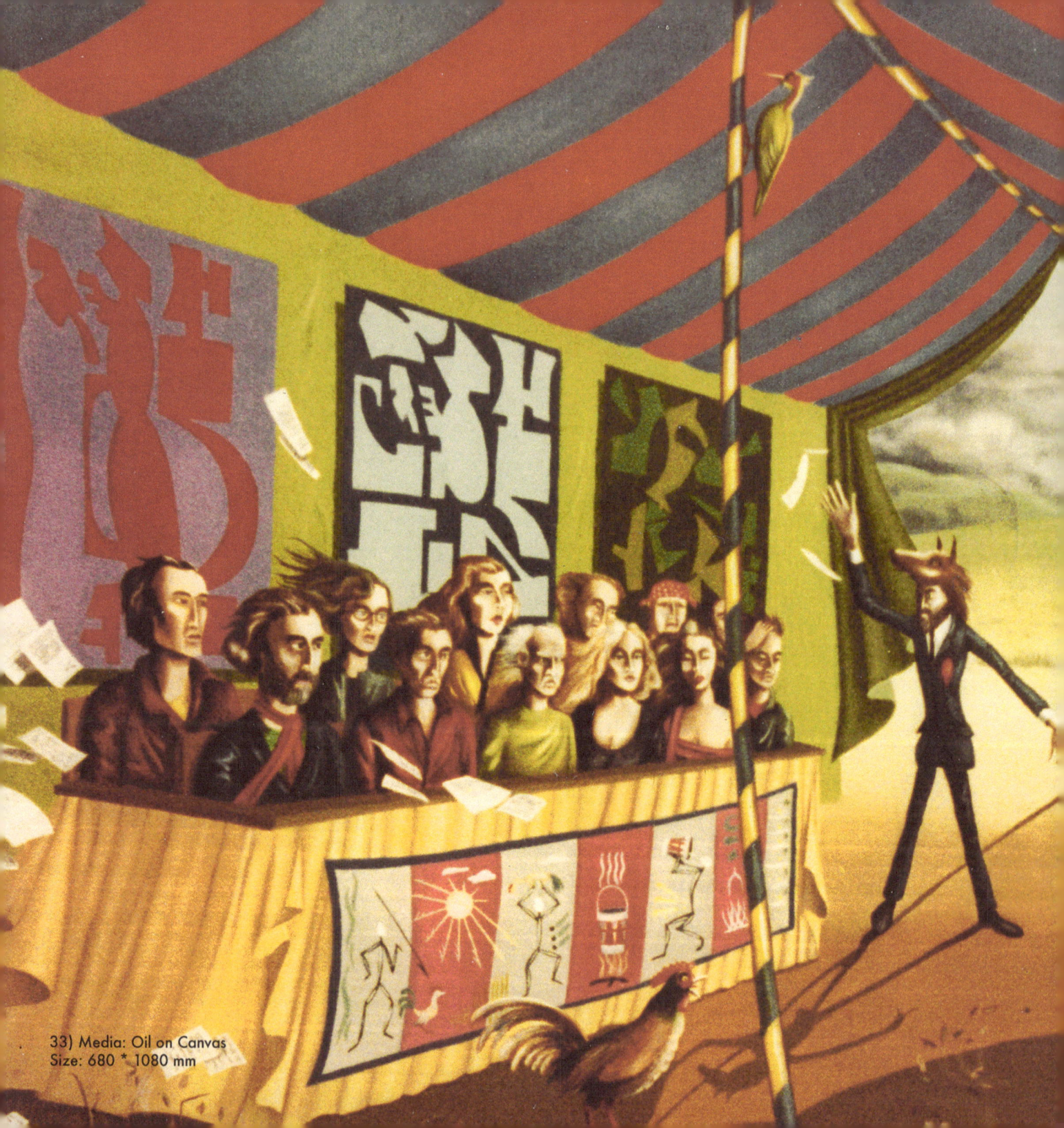

33) Media: Oil on Canvas
Size: 680 * 1080 mm

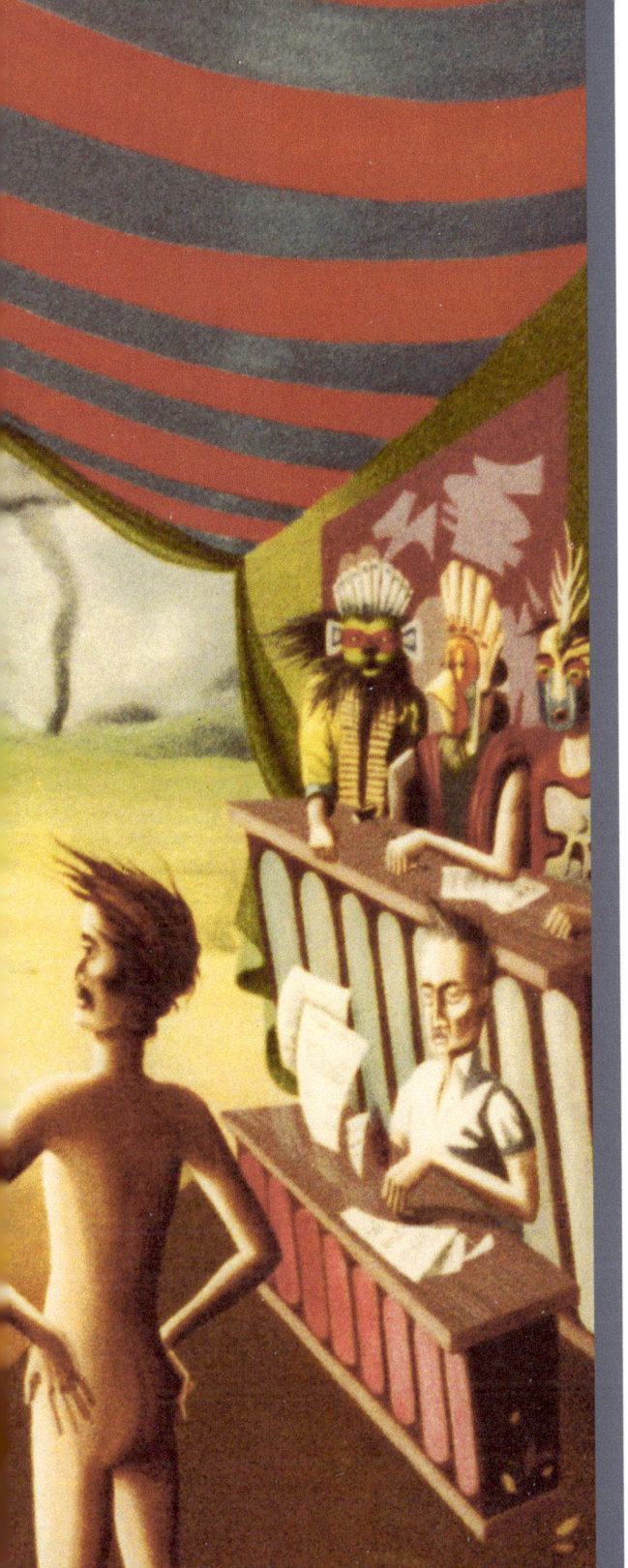

The Trial

What an awful predicament this is. The inevitability of the verdict appears to be most certain. The evidence is weak but the accuser is Incredibly convincing. He is very persuasive and is skilled at his trade. The masked judges are frightening indeed and the evil clerk orchestrates and records the proceedings.

The members of the jury don't really understand what it's all about and will most likely decide how they are instructed to do so.

On that day, with luck an elephant's tail whipped from the west and lifted the tent away.

Yet another close escape!

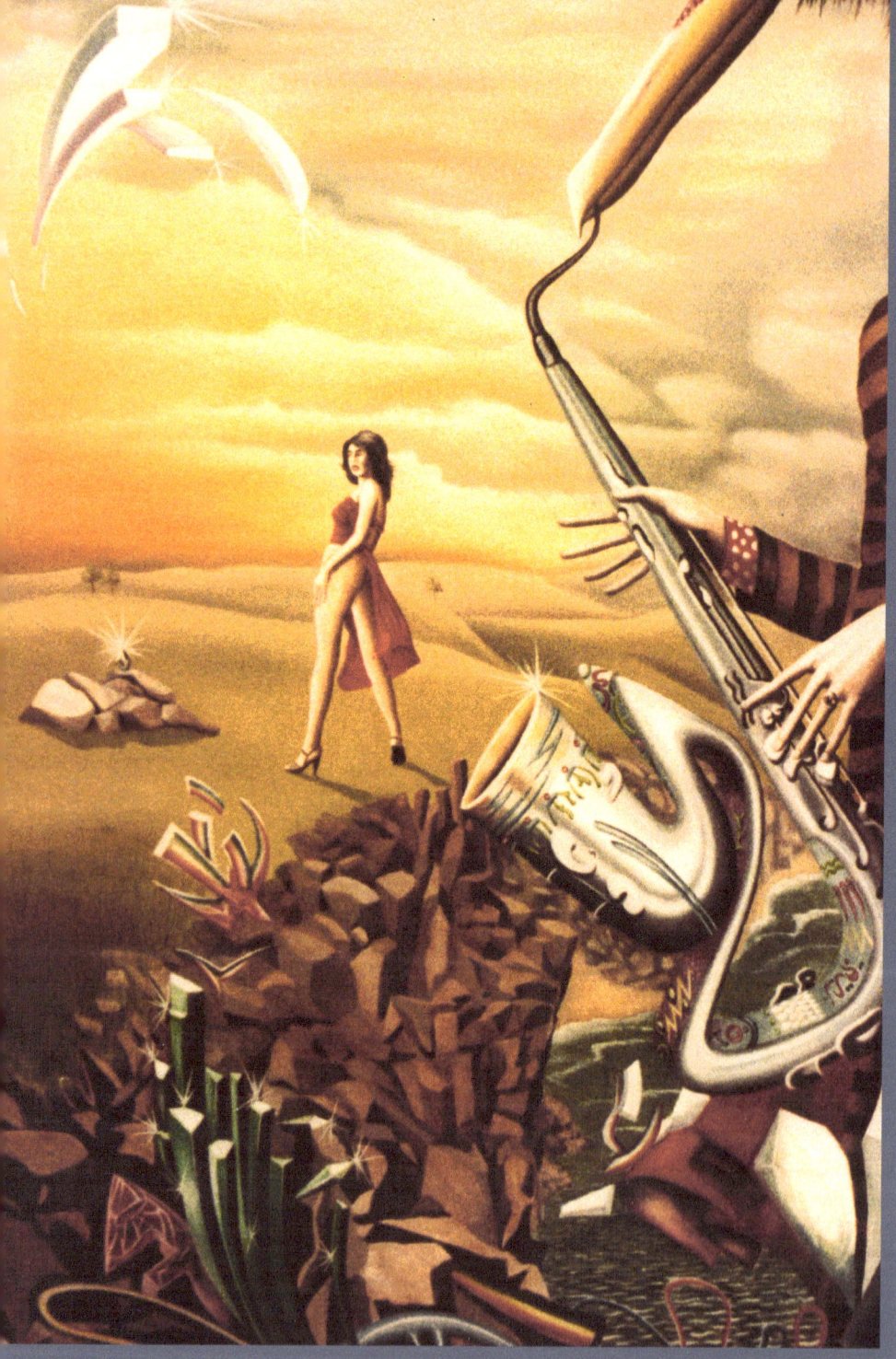

34) Media: Oil on Canvas
Size: 1080 * 680 mm

Little If Any

She will tempt you with strange treasures and her friend's accompaniment will seduce you, and lure you into her spell. Before very long her brew will send you spinning.

Remember that she rarely puts out, you'll never get to close this deal.

The music is enchanting and you might think that none of this is real. Certainly don't believe her, she's a deceiver. Even if you get there you'll never live to tell.

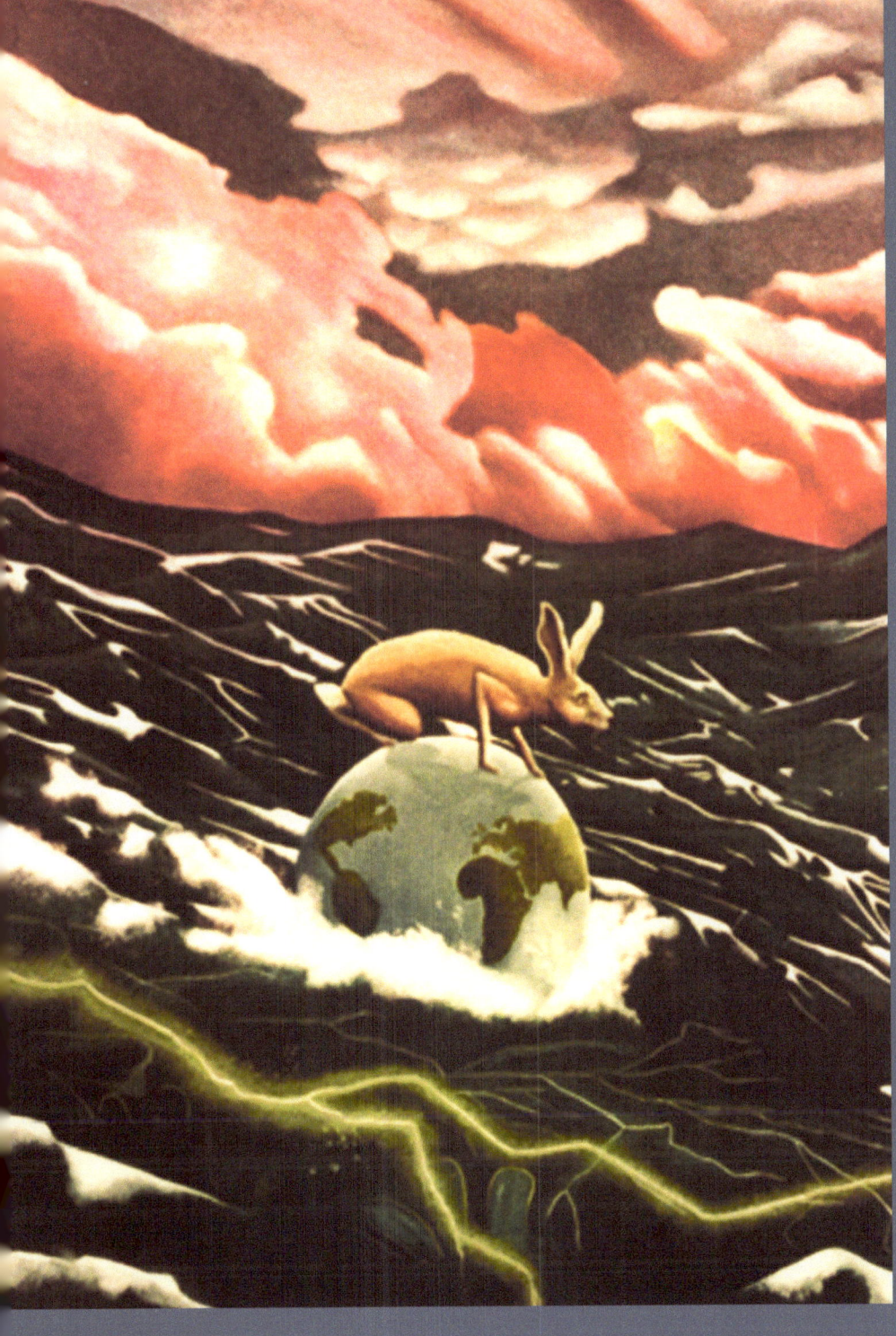

35) Media: Oil on Canvas
Size: 1080 * 680 mm

Top of the World

Everything moving all too fast, being carried along at a most uncomfortable pace and gripping on for dear life.

Feeling all so very vulnerable. The sky had turned to red and signaled great danger.

The peaks and troughs began to build and deepen. The result of this wish and ambition turned out to be very different to what was anticipated.

Sometimes the top of the world may not be the very best place to be.

36) Media: Watercolour
Size: 340 * 540 mm

One Step Forward & Two Back

Occasionally it seems as though the progress of our endeavors retreats almost as much as it advances. Oh what a pity that when it is our desire the passage of time does not do just the same.

Tune Hunting

Melodies and their arrangements are no different from any other form of ideas. Sometimes they come to us from apparently nowhere, and at other times they seem defiantly determined to remain elusive.

In our heads and hearts there are times when we are visited by far too many. On other occasions we must track them down, hunt them in order to capture and harness them.

Maybe it is that all tunes and other creative ideas already exist somewhere and have done so since the beginning of time and when we are fortunate enough to make contact with them we merely release them.

37) Media: Watercolour
Size: 540 * 340 mm

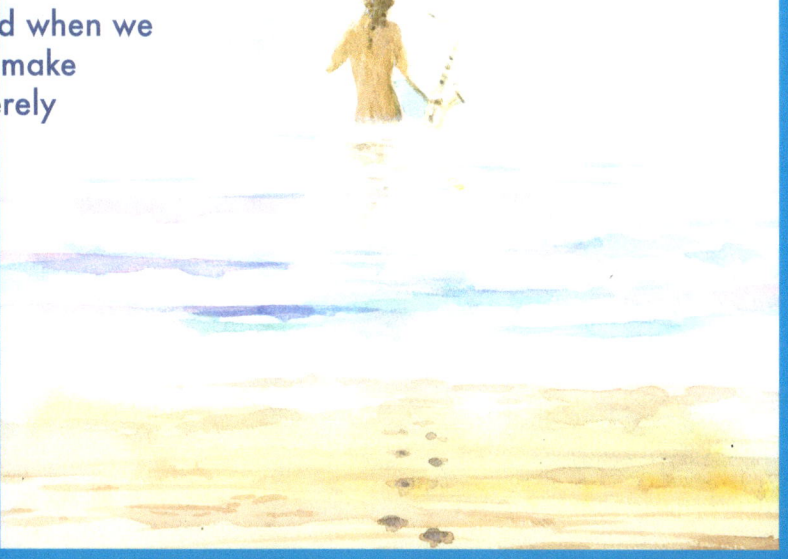

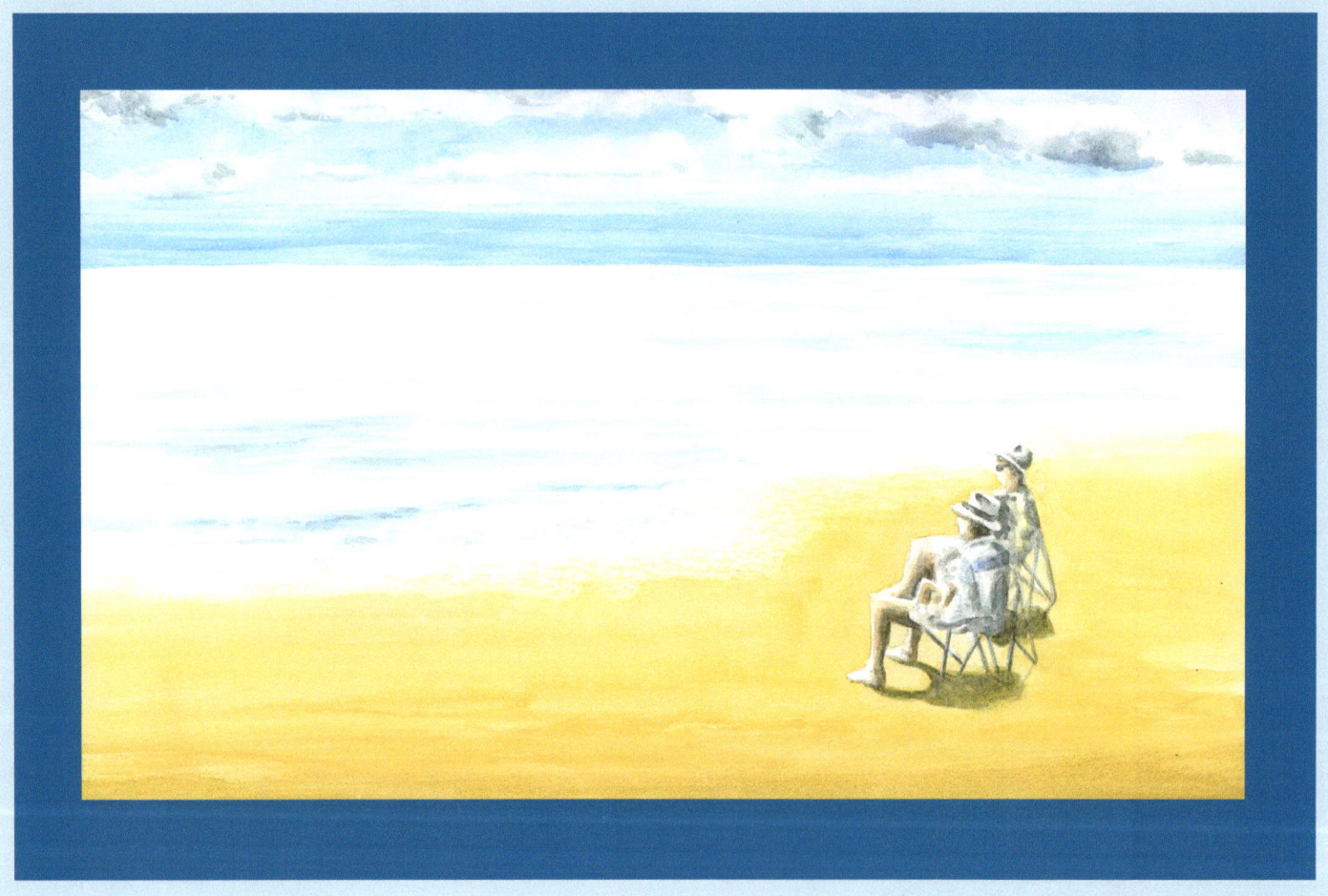

Tide & Time

It is said that the tide and time wait for nobody. However, sitting by the seashore watching and waiting for the tide to come in is a most enjoyable and relaxing way to merely allow time pass by at an acceptable pace.

38) Media: Watercolour
Size: 540 * 340 mm

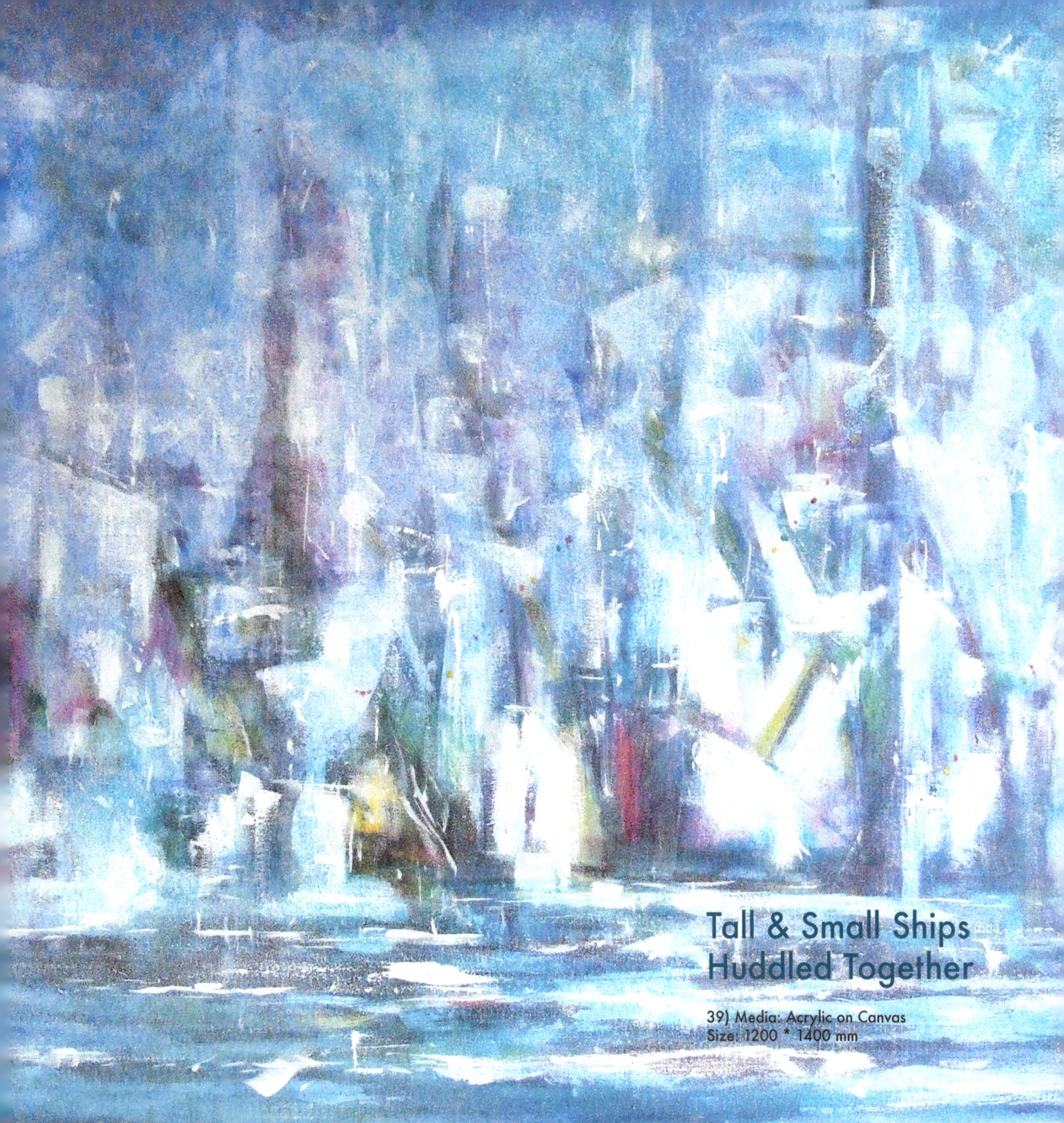

Tall & Small Ships Huddled Together

39) Media: Acrylic on Canvas
Size: 1200 * 1400 mm

Quantum

To consider the entire universe is probably the most far reaching thought that we can ever have, it's enormous vastness is near to being inconceivable.

There is however an opposing dimension that is almost equally unimaginable. The basic elements that of which everything consists of are so incredibly tiny it is utterly impossible to see them. We can only attempt to imagine their true shape and form.

The whole universe is an incredible and complex soup that's ingredients include every contributing molecule imaginable. We know this to be true but maybe there is even more to it than that.

40) Mixed Media
Size: 540 × 340 mm

41) Media: Watercolour
Size: 540 * 340 mm

Looking Down

We are often reluctant to think about or look at those things that may be of threat to us. The apparent security that this practice delivers is entirely false. To live in the belief that what we can't see or know about can't cause harm is fool hearty.

To have knowledge of and be fully aware of everything that is close or surrounds us is a far wiser practice to aspire to.

With that knowledge calculated decisions can be made, such as: 'Deal with it or get the hell out of there'.

Gone to the Moon

It's all so easy to go to the moon. No need to fly nor become an astronaut. Just wait until she visits the surface of the ocean then swim into her arms.

42) Media: Pencil
Size: 500 * 400 mm

The Dance

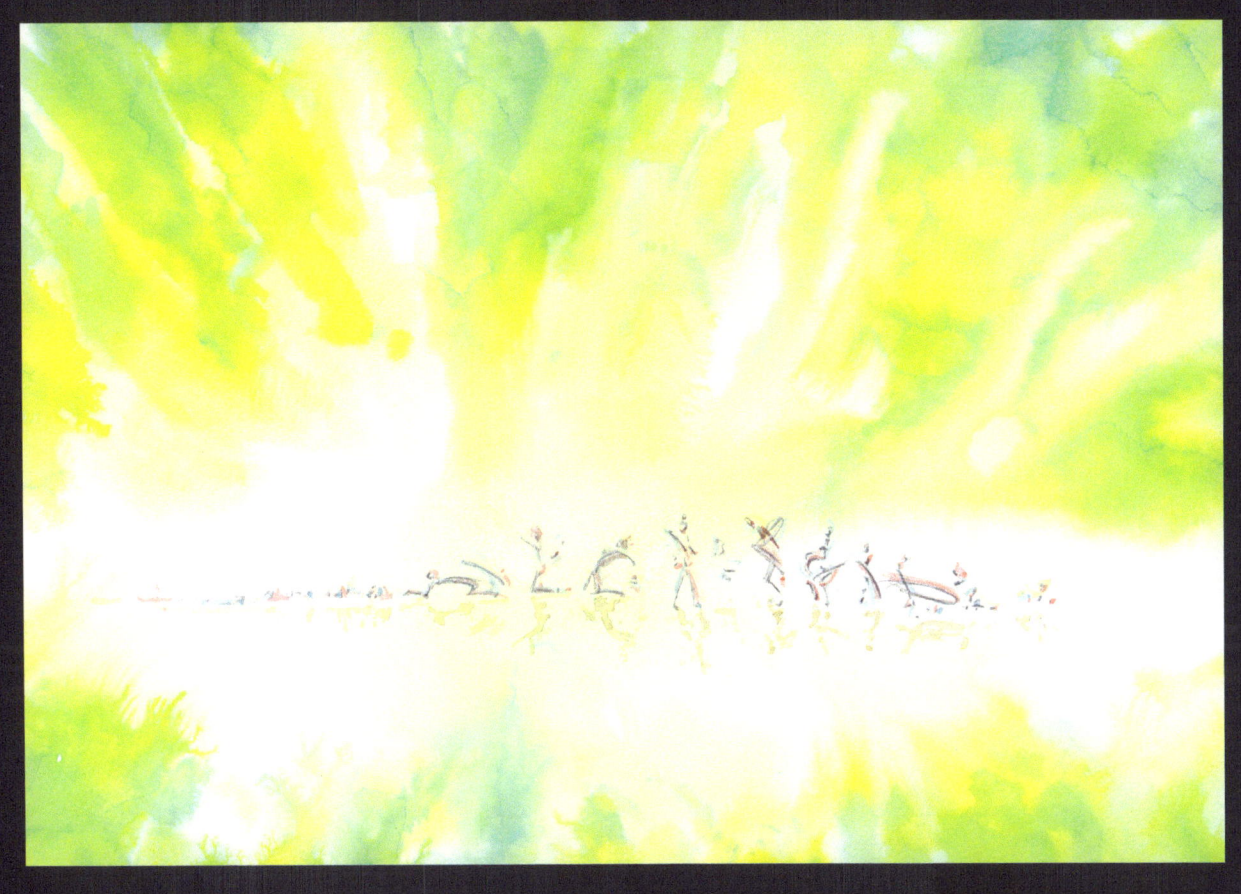

The dance is like a crystal tambourine.
A sight that's seldom seen.
Shapes of life against the screen.
A vision floating in a dream.

43) Media: Indian Ink
Size: 340 * 540 mm

Something Missing

Shadows can last long and sometimes give it all away. When something that is big to us has gone missing we can become extremely good at hiding the way we really feel.

The shadow that each of us casts reveals that which we might well prefer to hide.

Like puppets facing the lantern! Remember that it is only the details that shadows obscure.

44) Media: Indian Ink
Size: 340 * 540 mm

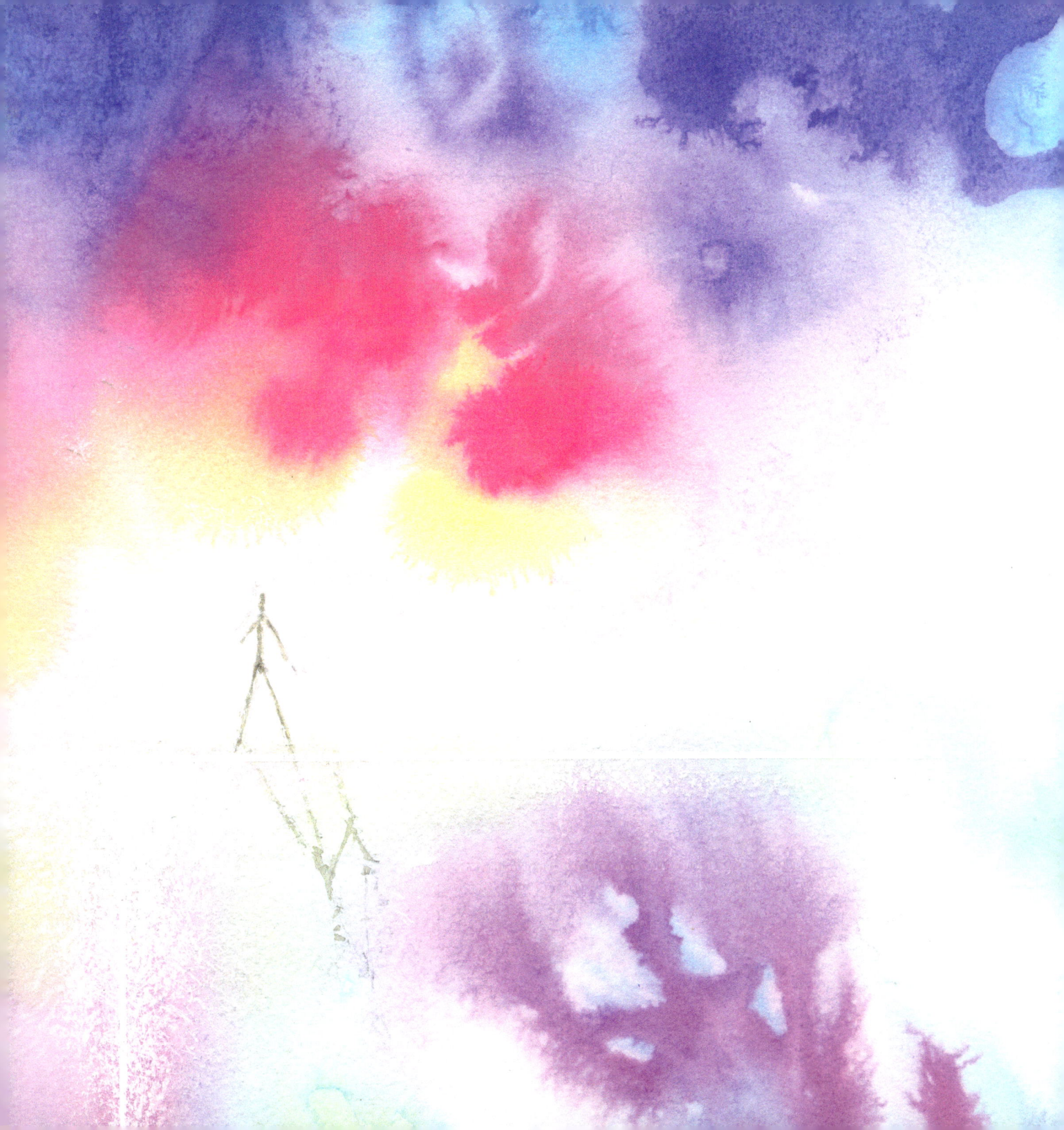

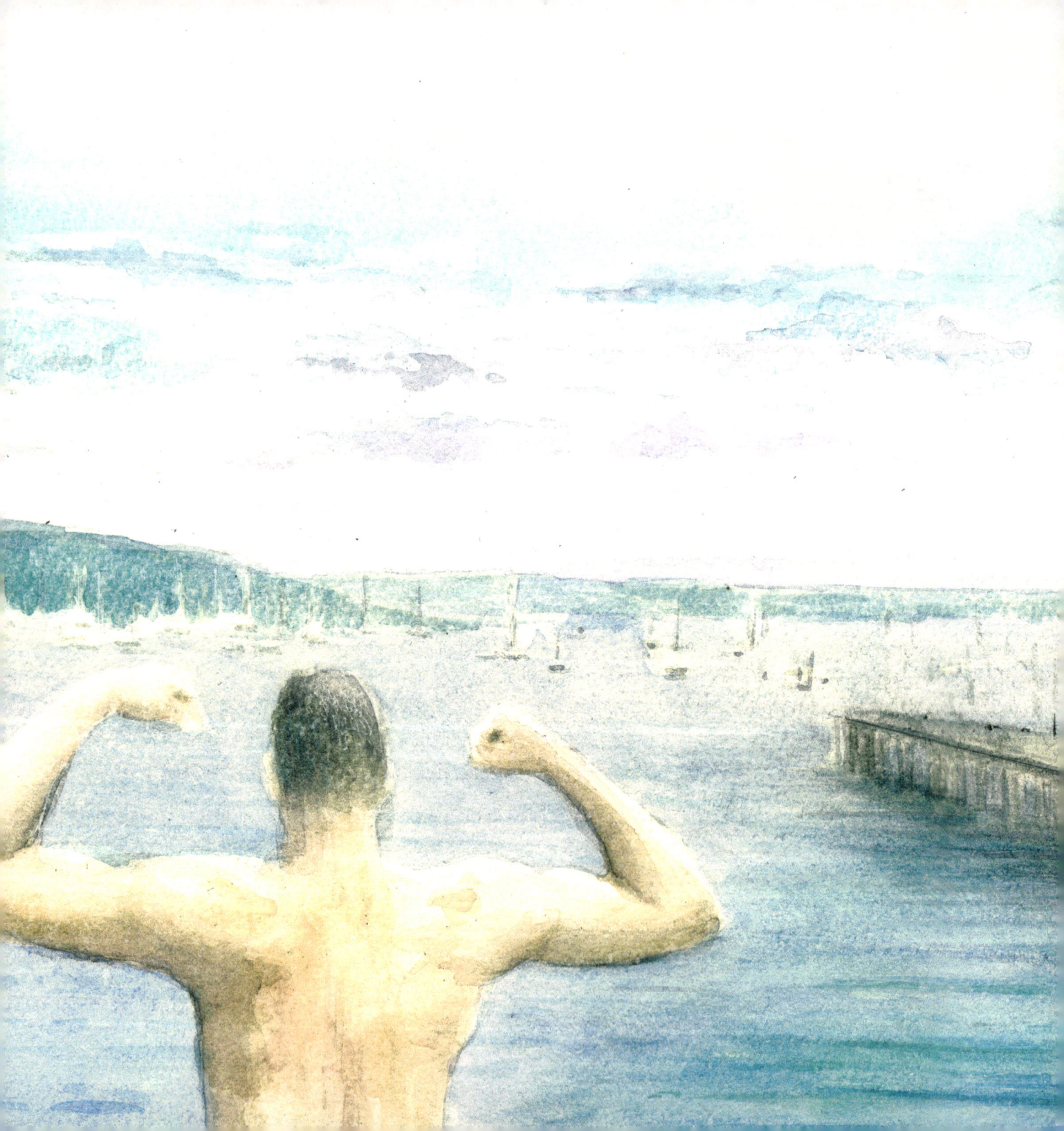

Freedom

It is the most precious jewel that anyone can possess. Some are fortunate enough to have been born with it. Others have to fight for it.

It can be lost or found, taken away, or even be given as a gift or reward. It can mean many different things and come to us in a variety of forms.

Many have died while trying to achieve it. Innumerable wars have been fought in it's name and to those who would steal it from us it's very name sends a chilling fear through their bones.

It is a thing to be embraced, cherished, and shared, a thing never to be thrown away or under valued.

The name that we call this treasure is 'Freedom'.

45) Media: Watercolour
Size: 340 * 540 mm

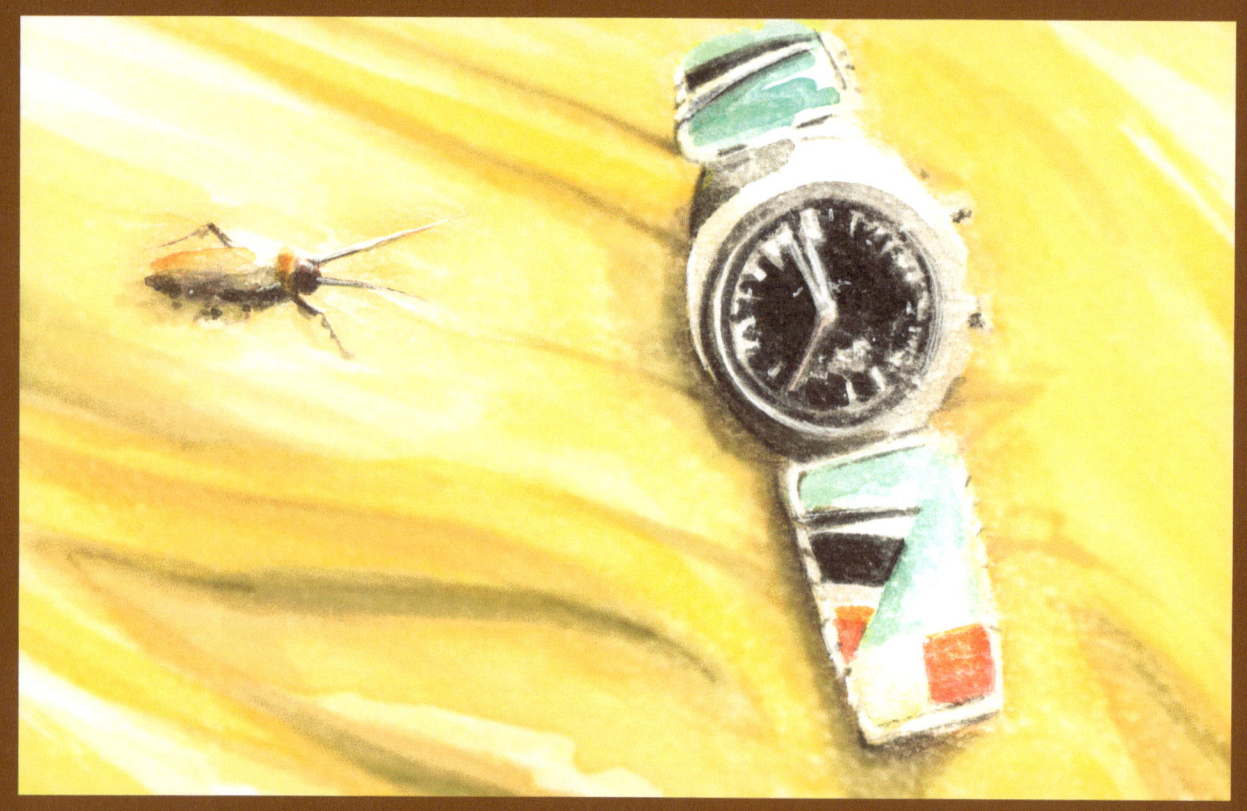

ClockRoach

Be it friend or enemy time is always with us. Each and every one of us is awarded a given and limited amount of this most valuable and essential commodity. By observing the sun, moon, and the changing seasons, or with the use of technological devices the advancment of time can be calculated. Be it good or bad, it is a fact that few of us really know how much of it we have left to spend.

46) Media: Watercolour
Size: 340 * 540 mm

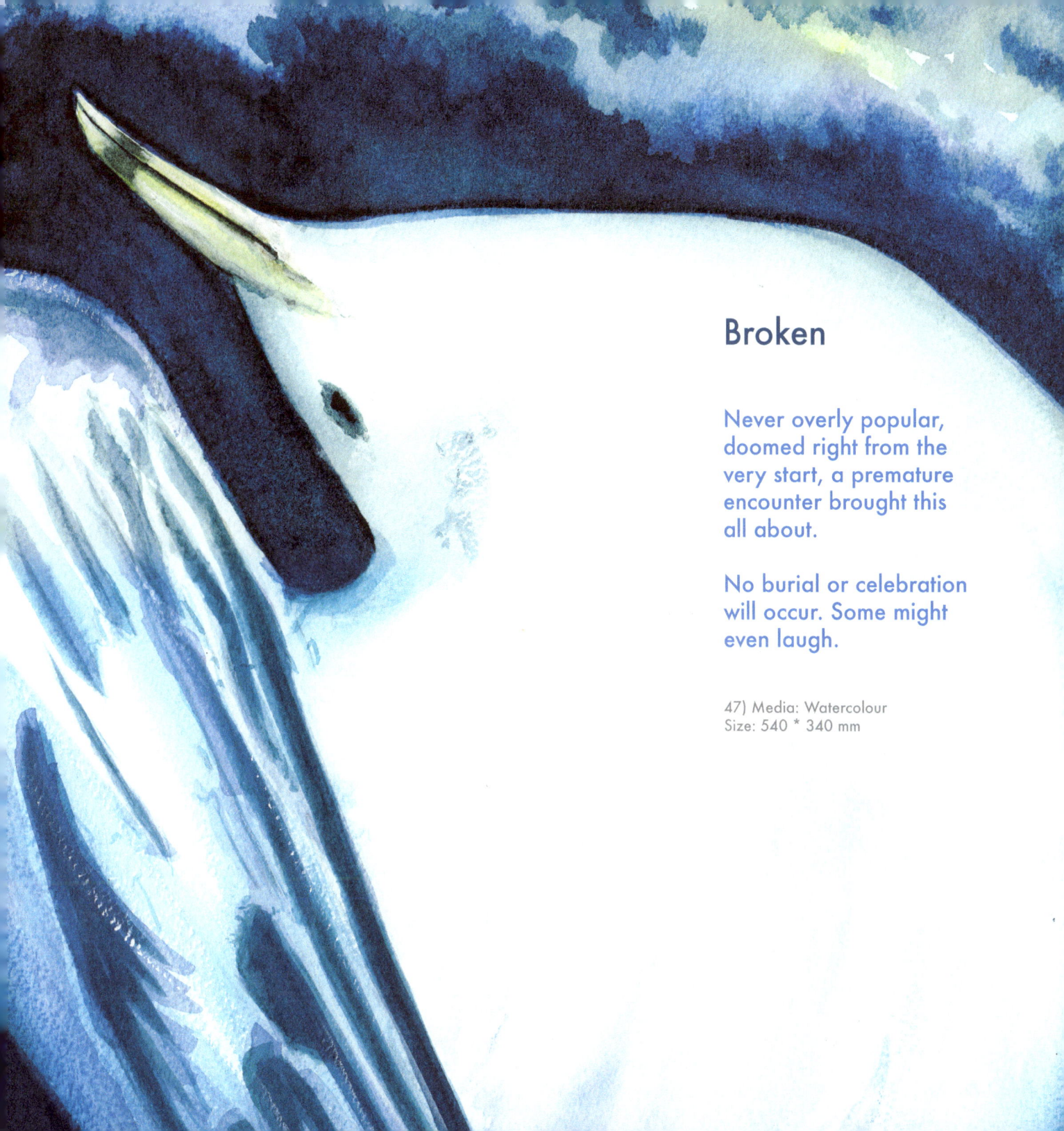

Broken

Never overly popular, doomed right from the very start, a premature encounter brought this all about.

No burial or celebration will occur. Some might even laugh.

47) Media: Watercolour
Size: 540 * 340 mm

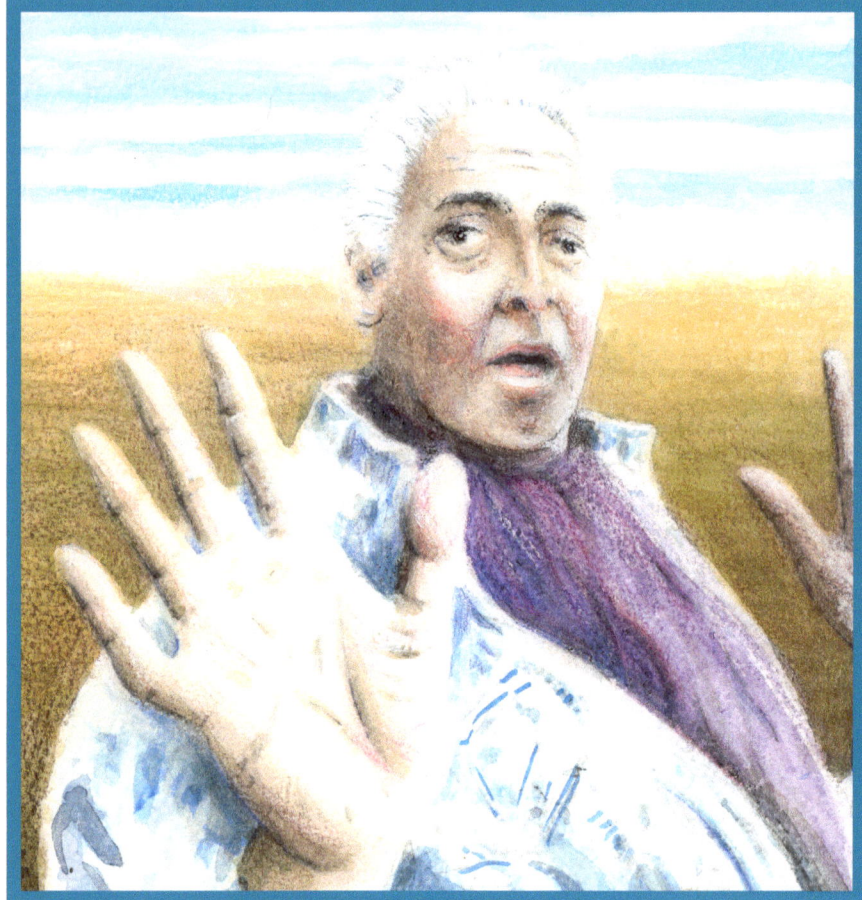

48) Media: Watercolour
Size: 340 * 340 mm

Another Surprise

Life is so very full of surprises. Throughout our entire lives in someway or another we systematically scheme and plan in order to map our futures. We dream and even sometimes prey that the future will be not very different from what we would hope for. However, it's life's endless array of surprises that makes everything so incredibly interesting. A chance encounter, an accident of timing, unexpected fortune, good or bad luck. All of these factors deliver surprises that can make or break us.

You yourself might state that you are in no need of any more surprises. Beware of even thinking such a notion. You'll definitely be surprised.

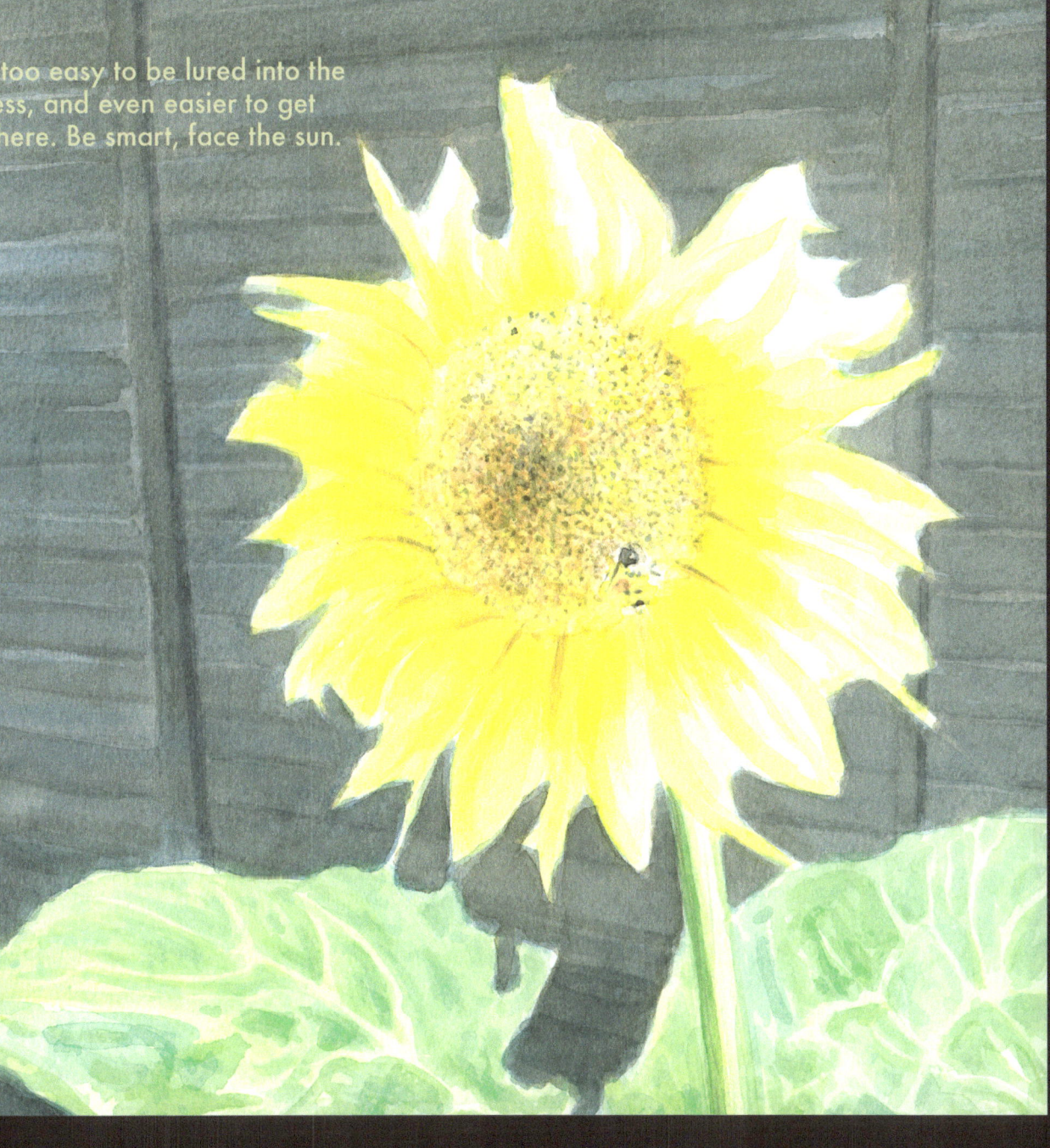

Facing the Sun

It's all too easy to be lured into the darkness, and even easier to get stuck there. Be smart, face the sun.

49) Media: Watercolour. Size: 340 * 540 mm

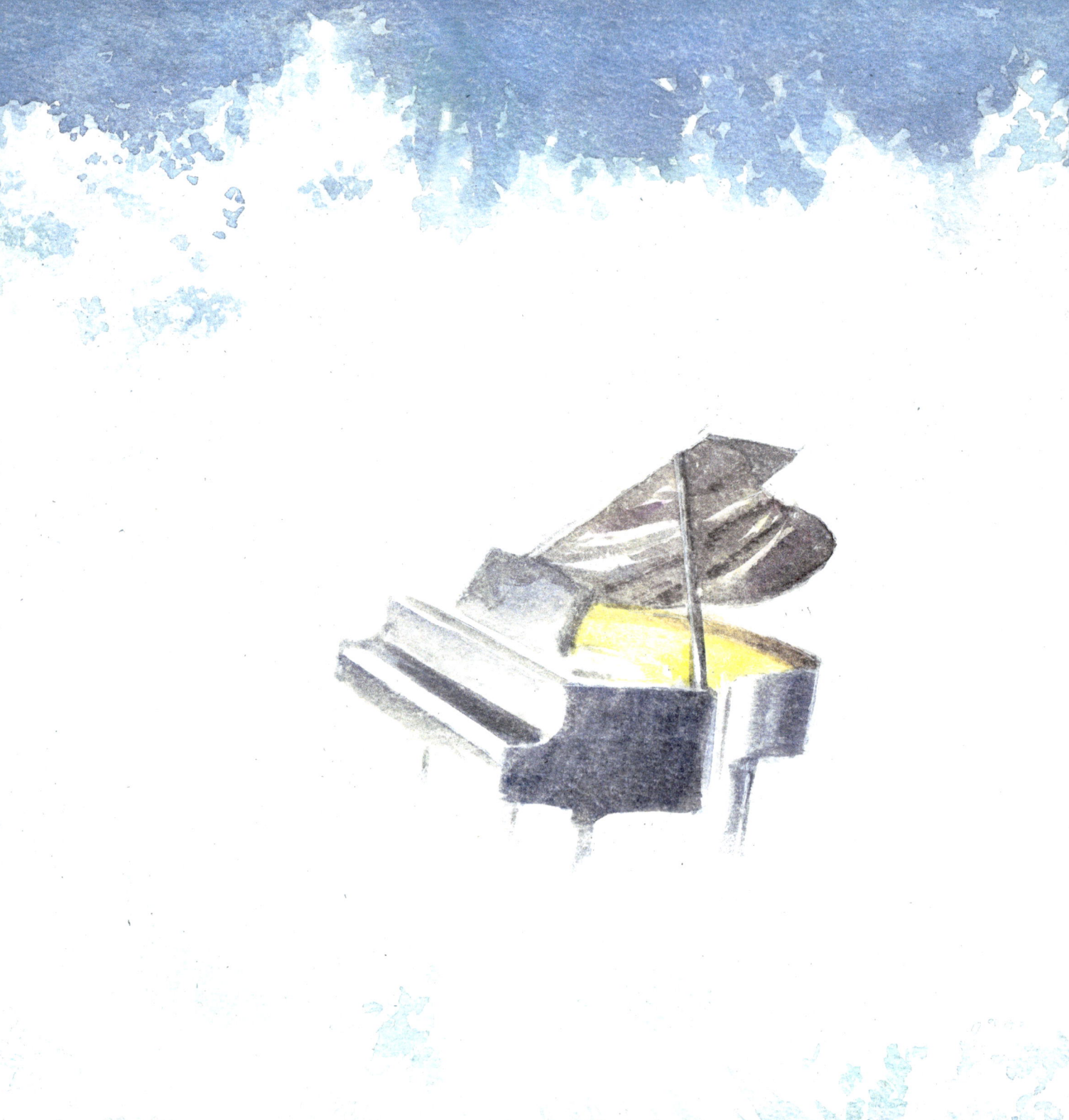

Pianist Disappeared

The music was of his own. Augmented and diminished chords he wove together into an amazing tapestry of notes. The high spring tides came to witness his extraordinary performance.

No one will ever know if it was his intention to take his music for a swim, or if it was an accident. Was it a disaster or an act of liberation? The deafening roar of the incoming crashing waves obliterated the sweet sound of his music and at the top of the tide one ginormous white horse engulfed both the pianist and his piano. As the fury of the tide abated and withdrew the piano was left bobbing up and down in the white foam. The pianist was never seen again.

Some people say that they have on occasion in between the sounds of breaking waves heard his music still coming from the ocean.

50) Media: Watercolour
Size: 340 * 540 mm

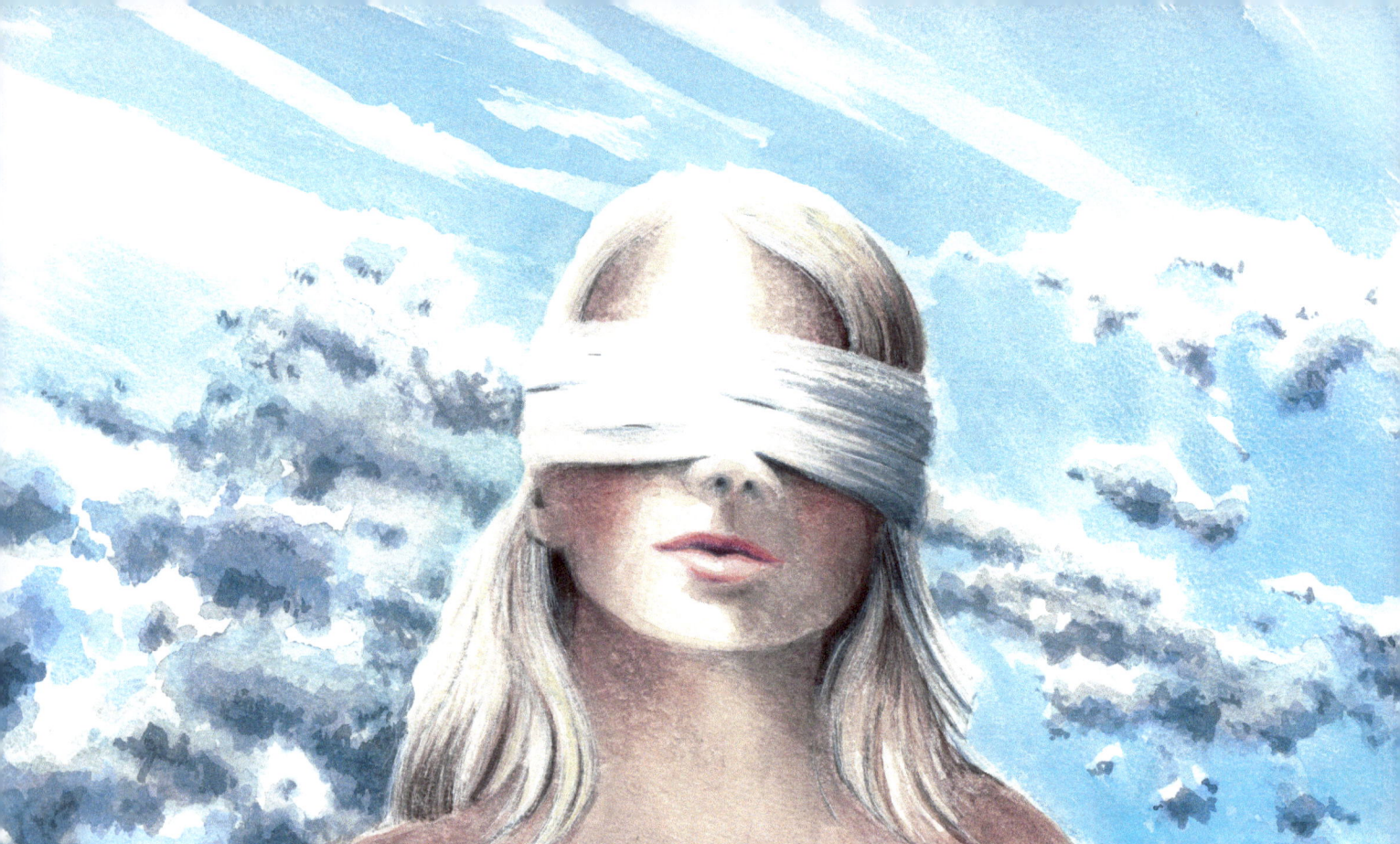

Andabata

51) Media: Watercolour
Size: 340 * 540 mm

Dawn brought little more than a dim grey light that found Andabata alone on the tundra. Andabata once lorded over this shoreline and beneath the moonlight swam between those proud rocks that protrude above the high tide line, and ran the paths that circumnavigate this domain. Andabata smiled at the journey past. Andabata heard laughter and the promise of joy coming from the rock pools. The secret cove where can be heard the water symphony is such a special place, it is there that this creature would meditate and understand that which had brought Andabarta to this coast.

Andabata is no ordinary gladiator. Andabata sees not with the eyes.

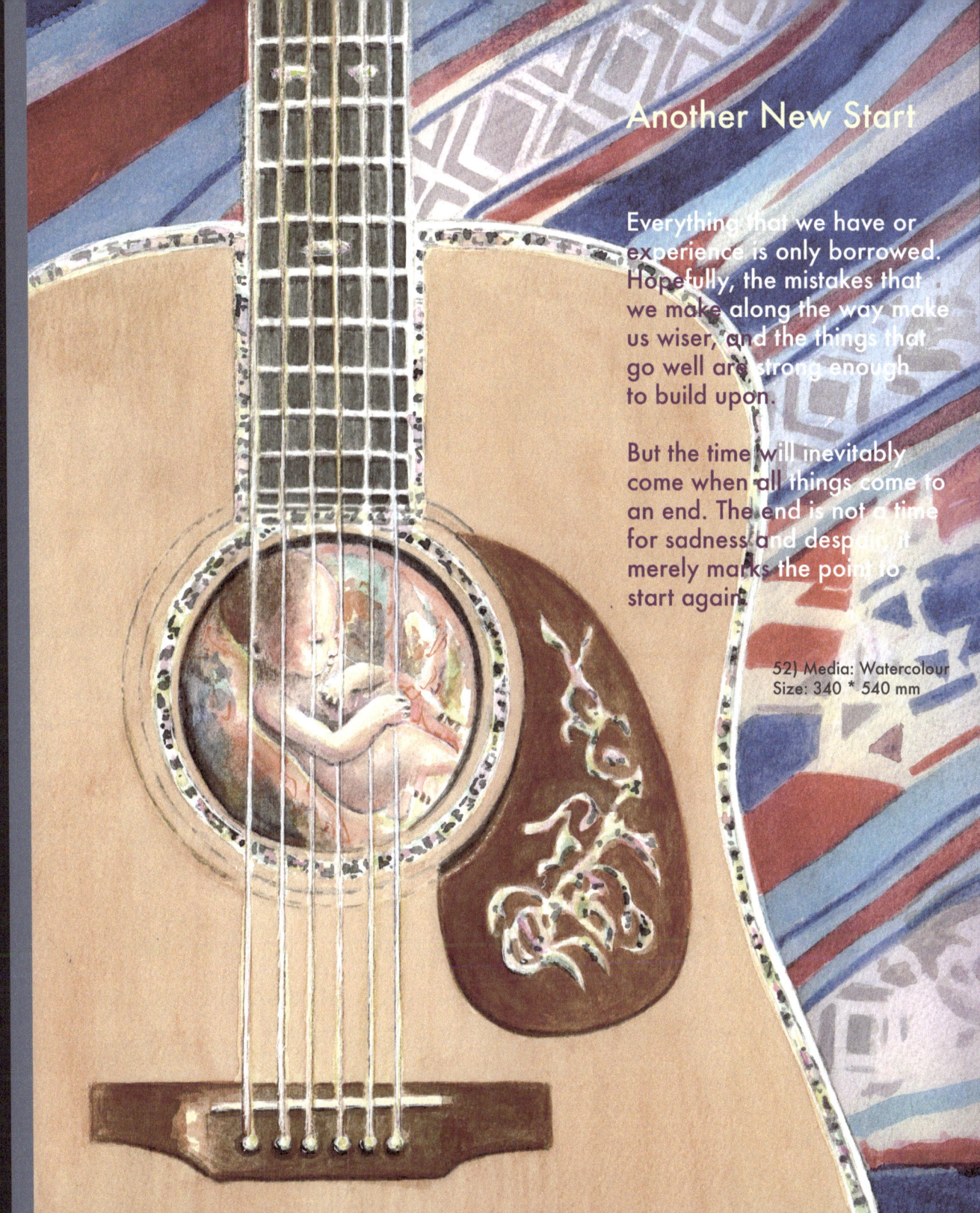

Another New Start

Everything that we have or experience is only borrowed. Hopefully, the mistakes that we make along the way make us wiser, and the things that go well are strong enough to build upon.

But the time will inevitably come when all things come to an end. The end is not a time for sadness and despair, it merely marks the point to start again.

52) Media: Watercolour
Size: 340 * 540 mm

Pause 53) Media: Pencil. Size: 210 * 297 mm

MIND'S EYE

Artwork by Al Cazu (Alan G Williamson)

Cazu

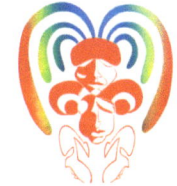

Productions & Publishing

email: mail@alcazu.com

tel: 07745606275

To view a full catalogue of artwork
by Al Cazu:
www.cazu.co.uk

www.ingramcontent.com/pod-product-compliance
Lightning Source LLC
Chambersburg PA
CBHW051051180526
45172CB00002B/598